intimate treasures_ _shooting jewellery

12-18 March 2016

exhibition catalogue

Published in 2016 by Textile Arts Factory
Thessaloniki Greece

© 2016 Textile Arts Factory

All rights reserved. No part of this publication may be reproduced or transmitted in any form or by any means, electronic or mechanical, including photocopy, recording or any information storage and retrieval system, without prior permission in writing from the author.

Limitation of Liability/Disclaimer of Warranty:
Information contained in this book has been obtained by the authors from sources believed to be reliable. However, they make no representations or warranties with respect to the accuracy or completeness of the contents of this book and specifically disclaim any implied warranties of merchantability or fitness for a particular purpose. No warranty may be created or extended by sales representatives or written sales materials. The advice and strategies contained herein may not be suitable for your situation. The authors are not responsible for any errors, omissions or damages arising out of use of this information. You should consult a professional where appropriate. Neither the Publisher nor Authors shall be liable for any loss of profit or any other commercial damages, including but not limited to special, incidental, consequential or other damages. Neither the publisher nor the authors shall be liable for any loss of profit or any other commercial damage, included but not limited to special, incidental, consequential or other damages.

EDITOR
Vasiliki Asaroglou

WITH THE COLLABORATION
Chrysa Xouveroudi

VISUAL IDENTITY & DESIGN
Ifigenia Kotitsa

foreword

Textile Arts Factory is pleased to present the "intimate treasures_shooting jewellery" exhibition catalogue of juried textile & fiber jewellery.
"intimate treasures" is an exhibition of the world's most fascinating textile & fiber jewellery
"shooting jewellery" is the exhibition of works by photography students of AKTO College Thessaloniki who interpreted jewellery artworks through the camera lens. A 3D animation student filmed the exhibition closing party at AKTO Thessaloniki Campus.
The call for entries received a remarkably wide variety of jewellery. The theme spoke to the artists and they responded most eagerly.
We extend our great appreciation to all who have contributed both directly and indirectly to this exhibition and catalogue. We would especially like to thank the artists, who participated in the exhibitions, Maria Fourtouni, head of education process coordination at AKTO Thessaloniki, and Chrysa Xouveroudi, art historian, for their precious guidance and support. We would also like to express our deepest thanks to Ifigenia Kotitsa for the inspired design of the catalogue. Appreciation is also extended to Ingo Dünnebier, Evdoxia Radi, Stergios Karavatos who contributed to the birth of "shooting jewellery". Moreover we give our thanks to the staff of AKTO Thessaloniki, each of whom has effortlessly assisted in the huge success of the closing party. A special thanks to Dimitra Kitsiou, who captured every moment of the closing party in film.

Vasiliki Asaroglou
Architect, Founder of Textile Arts Factory

amineh kazemzadeh
anca frantz
anna bonarou
anna perach
canan erdönmez
cecilia montague
joanna elefteriadou
klaus pinter
müjgan emre eroğlu
mustafa kula
natasha morris
neşem ertan ayata
oylum öktem işözen
özge erbilen yalçin
pelin demirtas dikmen
penelope parx
phoebe williams
piotr pandyra
thalia sidi

intimate treasures

all that glitters is not gold

Gold, shining like the sun and silver pale like the moon, have fascinated mankind from the moment they laid eyes on them, while discovering the world. The Sanskrit word hari is used to describe both the sun and the gold, underlining the importance of their relationship to the humans. Both symbols of power, with gemstones as precious companions to elevate their aesthetic and value, they captivate eternity. They claim the top aesthetic wise and also on the social and economic hierarchy, inevitably causing envy to those who cannot obtain them. There are wars raging in their name, and it makes one wonder if the game could be played on different terms.

Creation itself answers the issue and counter suggests more democratic and aesthetic solutions. Noble metals have always held a fascination but less noble materials, which bring an aura of intimacy, such as fabric also seem able to fascinate. They meet the human need to embellish their body, to determine their identity and culture, with textures and marks that trigger their sense and memory. Because fabric is the first feeling on the body from the moment we come to life, and colors are the vividness we enjoy in the world.

This was the philosophy behind this open call to the designers of the world and later behind the exhibition. Fabric, rope, string, all humble materials standing alone or alongside more valuable ones and complicated techniques featuring various cultures and creative effort, claim a strong aesthetic role. Glow doesn't always, but inspiration does, borrowing codes from the processing of the metal, the techniques of knitting, encouraging the eye to decode textures and technical peculiarities. And it is the touch that follows, enhancing the experience of different jewellery.

Finally, in this fascinating adventure of art, imagination and the hand of the creator that don't know molds and limits, recourse and another artistic genre, photography, to draw inspiration from textile jewellery. Young artists follow a creation path laid with fabric, metal, laces and colours, directing their own narratives, starring textile jewellery. The glow is born from the idea of creating without necessarily being gold.

Chrysa Xouveroudi
Art historian

amineh kazemzadeh

Amineh Kazemzadeh was born in 1963 in Tehran, Iran. She studied and trained as a painter in Tehran University art classes in the 90s, but soon shifted towards sculpture, working with a variety of materials such as stone, wood, bronze, fiber and textile, and techniques commonly regarded as feminine practices, like weaving, sewing and knitting. Her works mainly represent her concerns with cultural issues and challenges in her homeland, Iran with regard to its heritage and traditions, Modernization, and gender policies. Her works were included in about 30 group exhibitions and 2 solo exhibitions in galleries like: Shirin, Saba Art Gallery, Iran Artists Organizations, Imam Ali Museum, etc. She has received several national and international awards and has been a member of the Iranian Sculptors' Association.

The presented works belong to a collection, inspired by Persian traditional geometry and floral motifs. The floral motifs are drawn from the old Persian carpets which were usually handwoven by women and children to decorate and cover the floors. These handwoven kilim and textile jewelries have been designed and made as striking ornamental objects for women, who are mainly ignored and remain unseen in the history of Persian traditional arts and crafts.

contact details:
www.a-kazemzadeh.com
a.kazemzadeh@gmail.com

bottom right
Persian flower

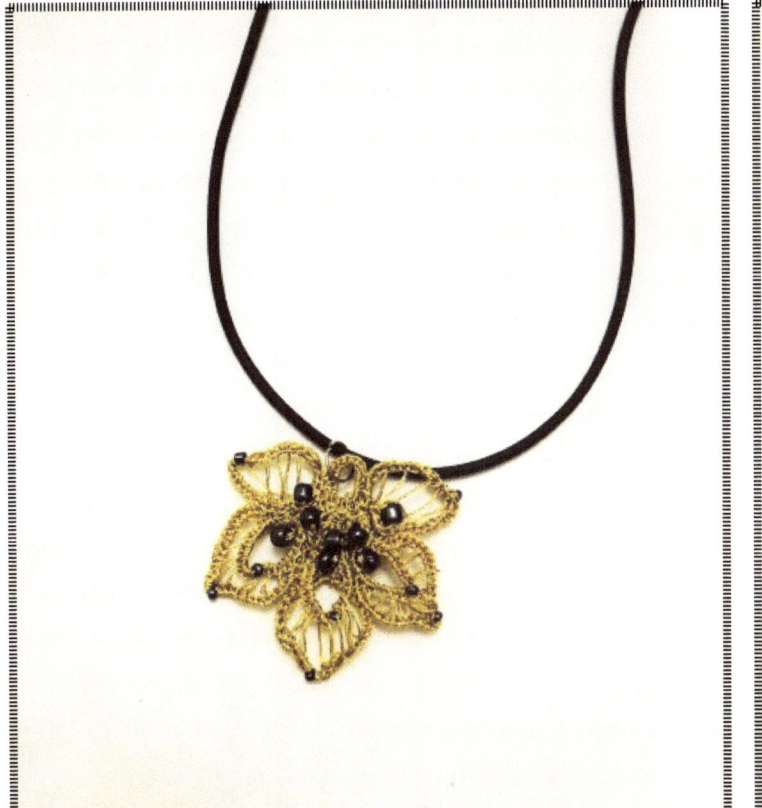
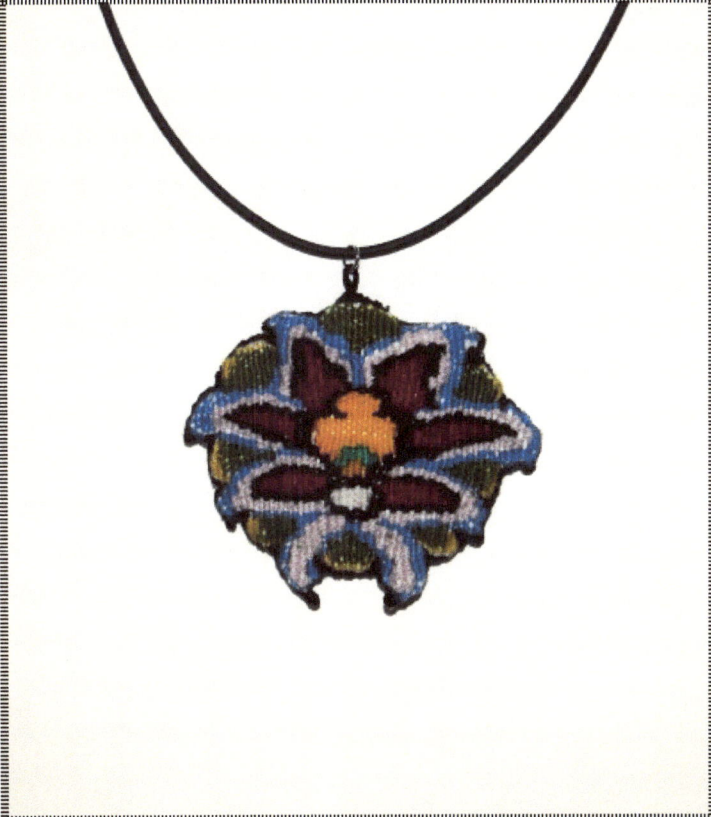

anca frantz

Personal Dates:
Family Name: Frantz
First Name: Ancuta
Date of Birth:16-05-54
Nationality: Romanian
Professional Education:
1973-1977 ACADEMY OF FINE ARTS CLUJ-NAPOCA -major course of study: Textiles
1970-1973 High School of Fine Arts Cluj-Napoca)
Professional Experience:
1977-1991- fashion designer
1986-1989 - university assistant at Academy of Fine Arts Cluj-Napoca Romania
1992-2004- fashion designer
2005- Current-- freelance artist
Artistic activity:
From 1976 I participated at all county and national exhibitions of Decorative Art in Romania
1979 and 1986 Personal exhibitions of tapestry at Art Gallery Bistrita and Cluj-Napoca Romania
Participations at fashion shows with personal collections in Cluj-Napoca and Bucharest 1986, 1987, 1989, 1990, 1992, 1994, 1995, 1996, 2001, 2003
2009 I started to exhibit art quilts in: Lancaster USA, Phoenix USA, Bucharest Romania, Birmingham England, Veldhoven Nederland, Heidelberg Geremany,
I have art works in the collection at the Bistrita Art Museum-Romania, Cluj-Napoca Art Museum-Romania private collections from Romania, Germany, Nederland, USA

I came to art quilt via a trail of all my creative passions. Art quilting is a convergence of my artist and quilter selves.
My path has led from fashion designer, weaver, painter to art quilter. Art quilting combines all these skills and more. While working on my art quilts, I enter a zone that combines all of these creative expressions. There are many steps and processes involved in completing each piece.- designing, researching, selecting fabric, sewing by hand and by machine, seeking inspiration, and then some.
I am convinced that the only way one can stay current and create original work is by allowing oneself to experiment, to have failures. With failure comes the opportunity to go in a new direction.

contact details:
frantz.ancuta@gmail.com

Letter from home

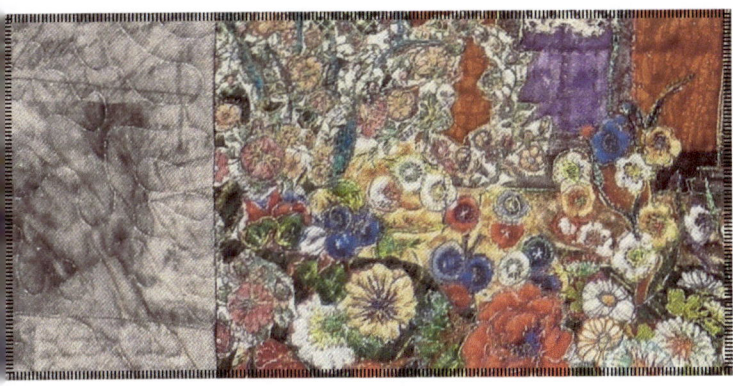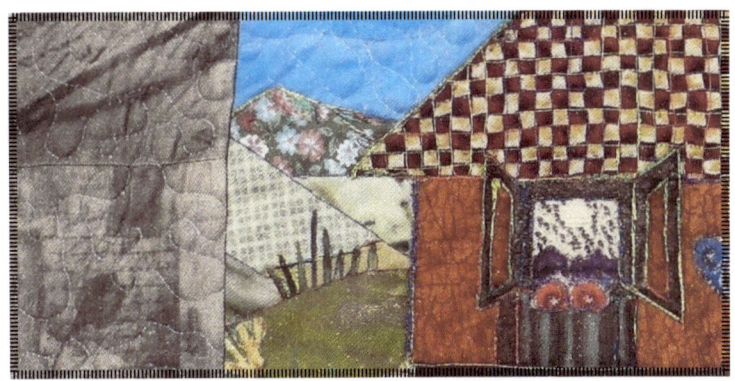

anna bonarou

Anna Bonarou graduated from Architecture and got a Master of Arts in Education. She teaches art & design courses at several institutes and colleges. As an artist, she explores various techniques of modifying textile surface like dyeing, stitching, painting, cutwork, etc.

contact details:
www.annabonarou.com
www.textileartsnow.com
annabonarou@gmail.com

Fiber chain

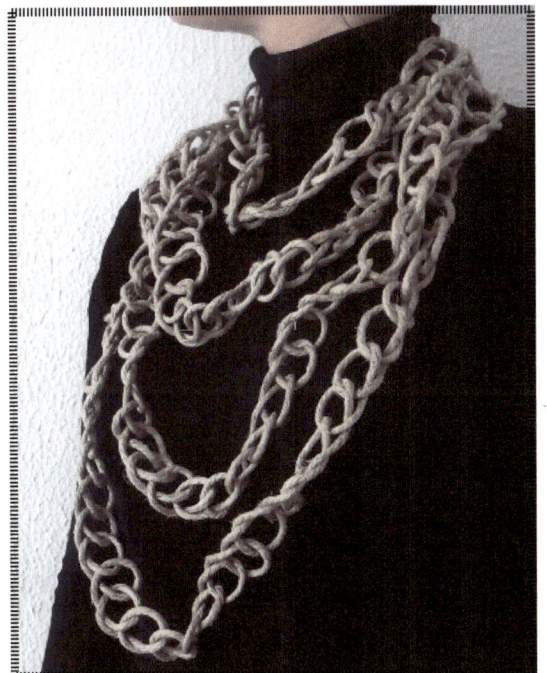
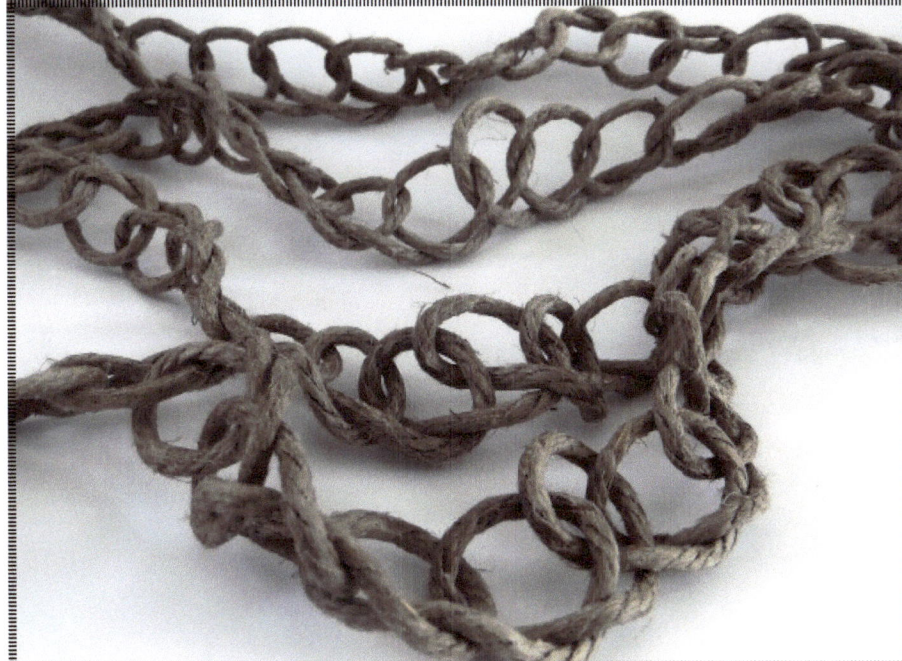

anna perach

Anna Perach holds a BFA from Bezalel Academy of Arts and Design in Jerusalem,
She currently lives and works in London, UK.
She has exhibited her work in Israel, UK, and Greece.

Anna Perach is a multimedia artist, working in a range of mediums including video, sculpture, installation and traditional craft techniques. The main theme of her work is the experience of shifting and adjusting to different cultures. Through her works she examines and deconstructs the aesthetics and physicality of her surroundings. As an immigrant from the Soviet Union to Israel, this aesthetic is rooted in Eastern European, Soviet culture and its encounter with the Middle East.

contact details:
www.najibakitai.com
an85kt@gmail.com

top left to right
Chicken legs
Pipe
bottom
Firebird

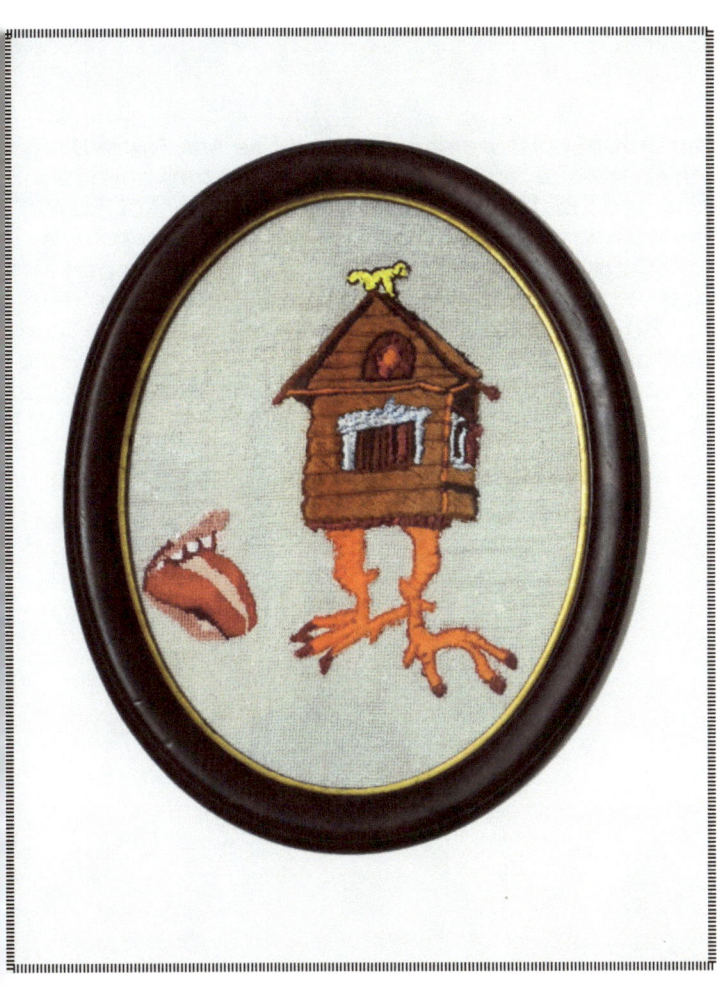
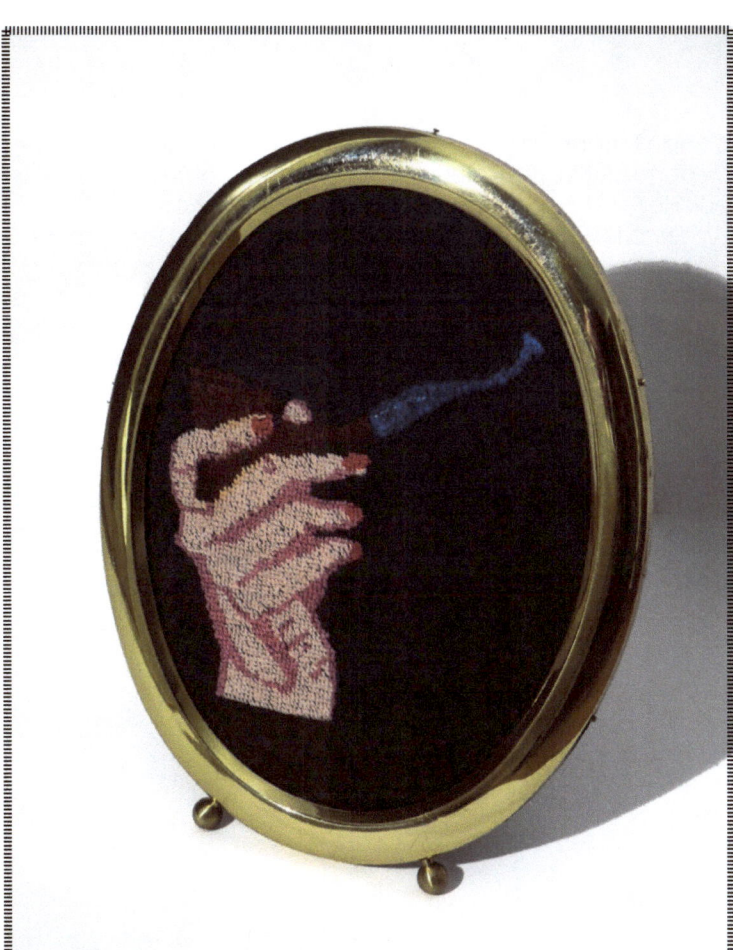
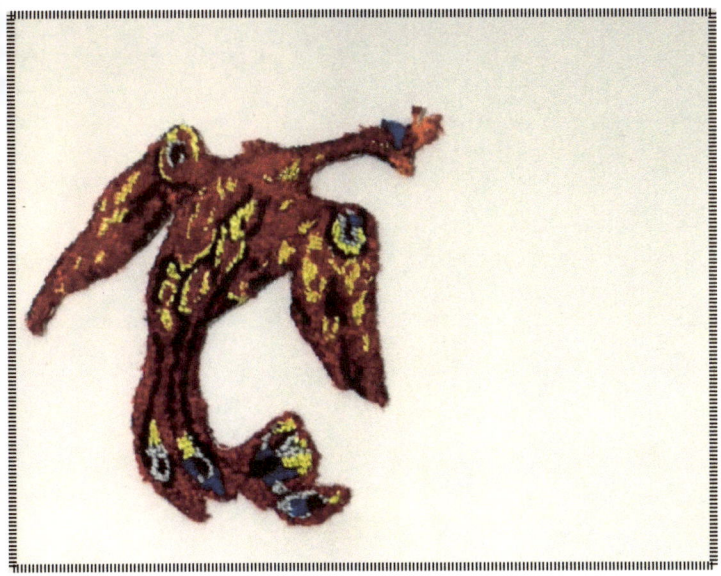
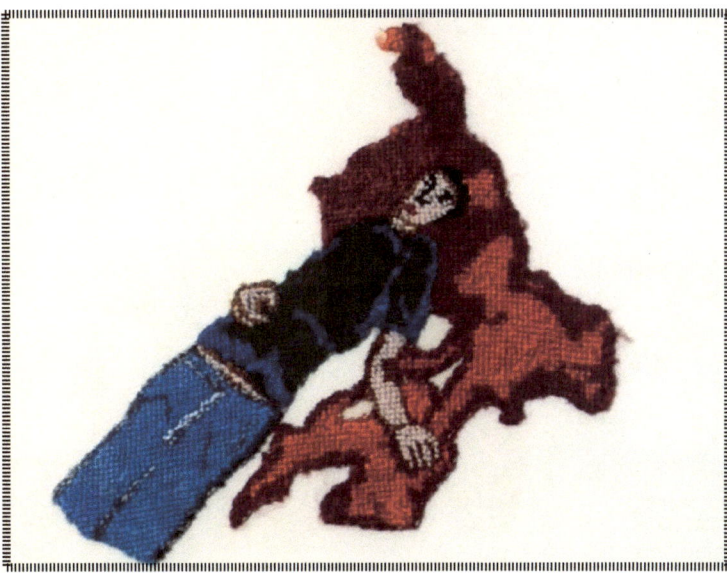

canan erdönmez

Canan Erdönmez was born in Bitlis in 1973. She was graduated from Dokuz Eylül University, Faculty of Fine Arts, Textile Design Department in 1997. Her work experience comes from working in the private sector for companies both in Izmir and Istanbul. Her professional career started in 1999 when she started working as a teaching assistant at the Department of Fashion Accessories Design, Textile and Fashion Design Department. Erdönmez, who continues to pursue her academic career in leather, leather accessory design, and history, with published in national and international articles, completed her postgraduate degree with her research on 'The Change in Female Shoe Fashion between 1900 and 1950' at Dokuz Eylul University, The Institute of Fine Arts Textile Design Department in 2010. In 2011, she conducted a research at Toronto Bata Shoes Museum on the subject of "Twentieth Century Female Shoe Fashion" and "Native American Culture Shoes." The artist, who previously acted as a coordinator and has been a jury member for Leather and Leather product design contests, took part in the executive committee of Izmir Leather Design and Production Contest as a design consultant between the years 2011 – 2014.

The artist, whose work has been displayed at numerous national and international exhibitions, prefers especially natural materials for her three-dimensional works, and uses leather as her main material.

Creation 1: Having been practiced by inspiring from migratory bird, 'Together' is a composition made by leather and lasso.
Creation 2: Canan means the beloved darling. Complications of a relationship has been interpreted by knitting method in this work. Performed with leather thongs, knitting was put in the final form by writing Canan in Ottoman Turkish in with silver.

contact details:
canan.erdonmez@gmail.com

top
Together
bottom
Beloved

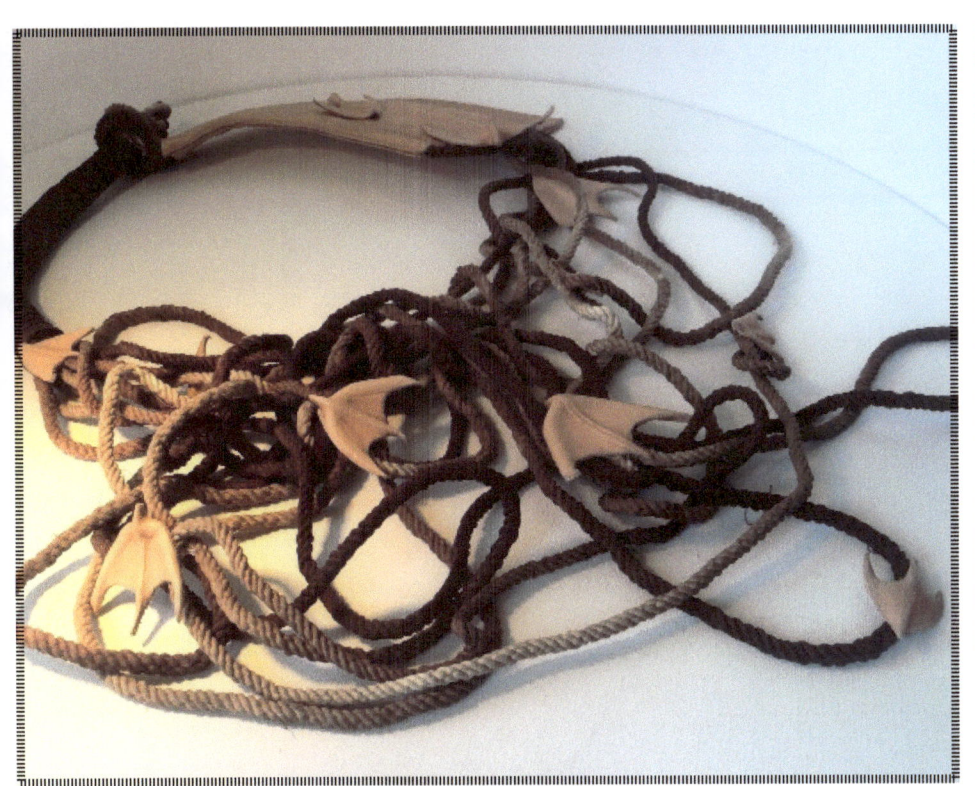
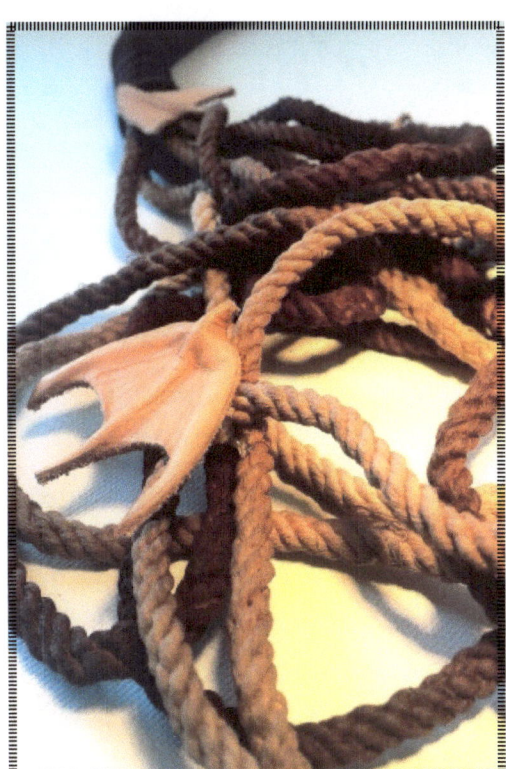
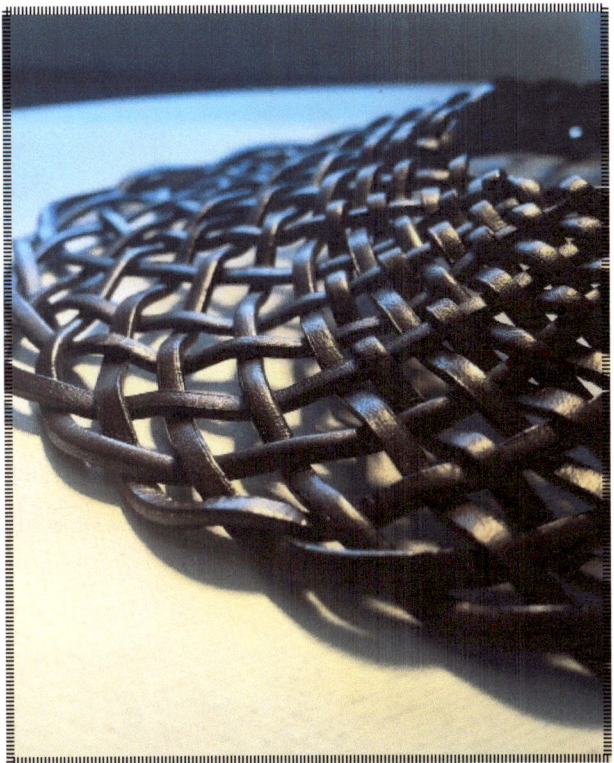
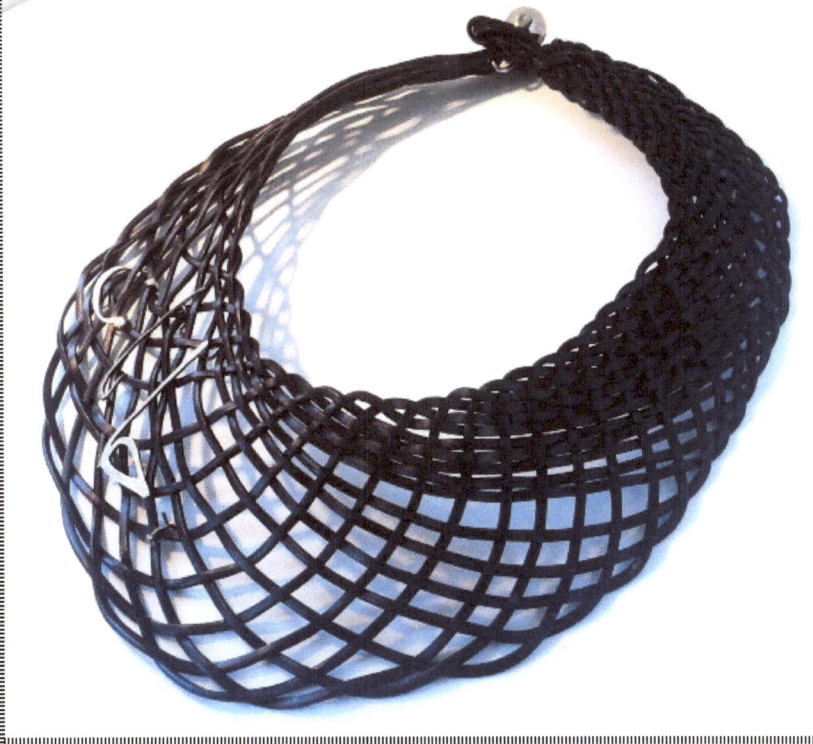

cecilia montague

Types of Art: cartooning, drawing, jewellery, embroidery
Training:
2007 – 2009 Design @ ST.J.C.C. Cork
1992 – 1996 Fine art @ C.C.A.D., Cork
Courses:
2012 Marketing / Sales
2010 Art history
2009 Computers

I am inspired by nature, fashion and people. I trained as a professional jewellery designer in Cork . As an artist I practise jewellery making, embroidery, and cartooning.

contact details:
www.outsidein.org.uk/ceciliamontague
c.m.artist0@gmail.com

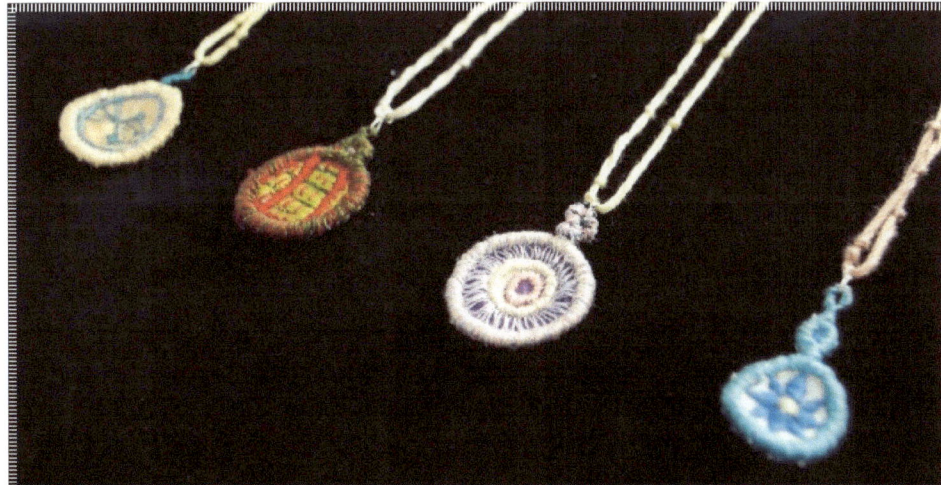

joanna eleftheriadou

I have been working in a French multinational corporation as an executive for 21 years. My search within the artistic sphere comes from my experiences while in the wild. I express my inspiration and concernment through natural materials and depict joy.

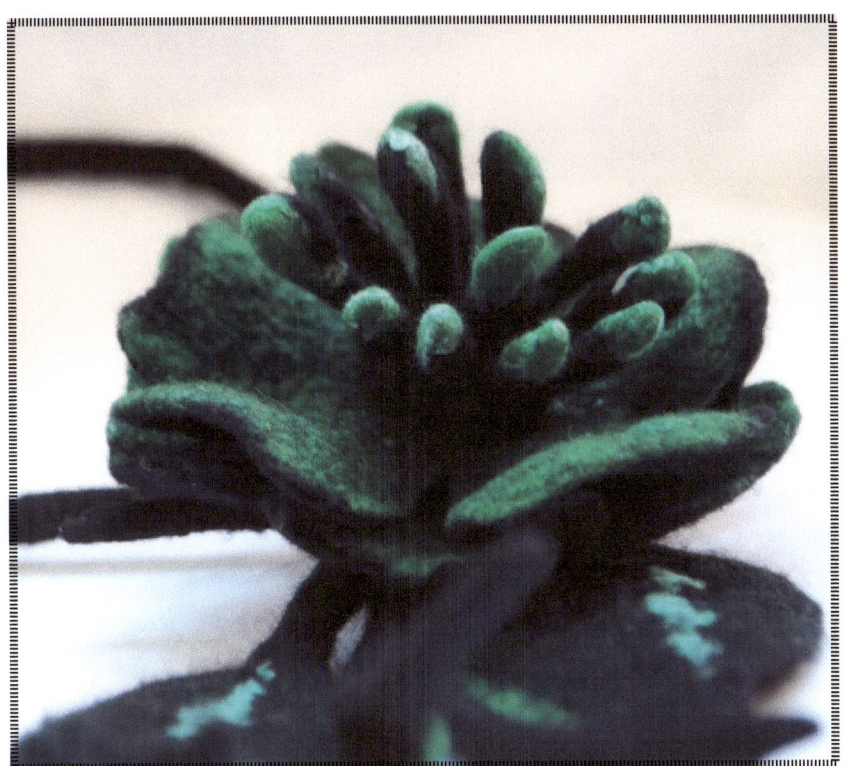

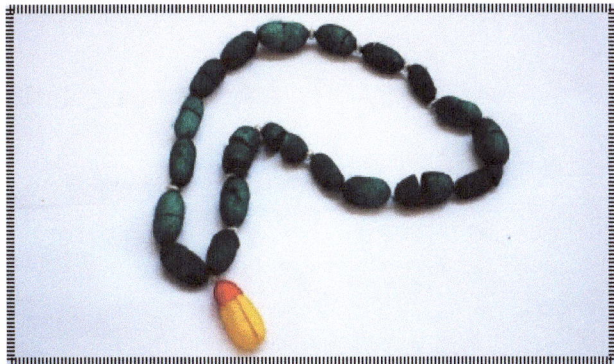

klaus pinter

1968
lives and works in vienna

Through interactive engagement leading to the transformation of a wall art into sculpture, the piece shifts into a substantively different level of interpretation.

contact details:
www.klaus-pinter.net

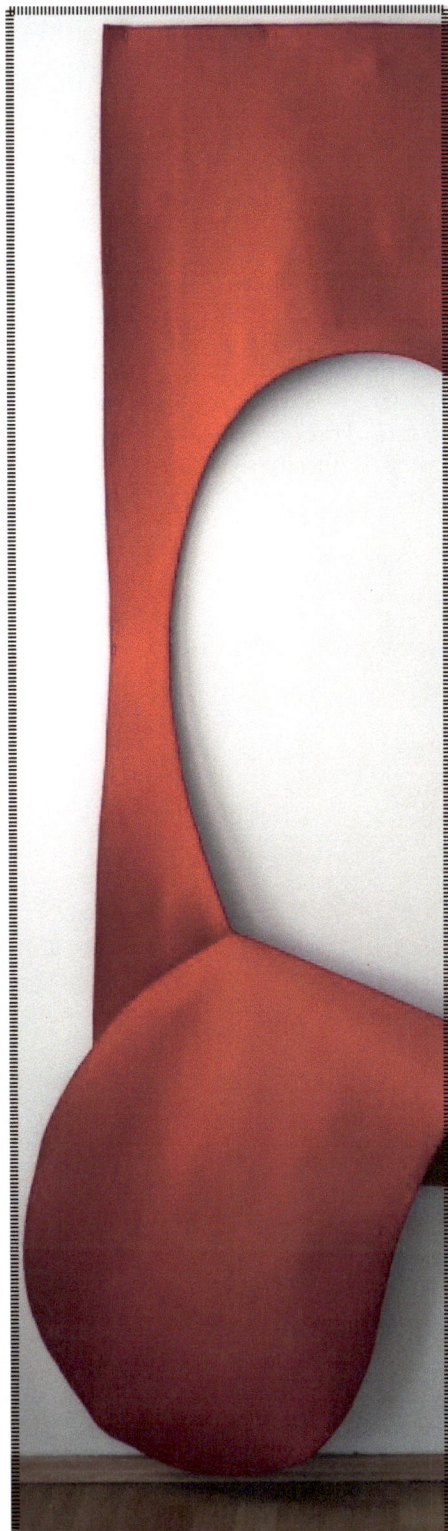

müjgan emre eroğlu

Müjgan Emre Eroğlu was born in 1972 in Izmir. She was graduated from textile major, fashion and accessory design programme of Dokuz Eylül University faculty of fine arts in 1996. Since 2002 she has been carrying on her academic career, which she started in Milas Sıtkı Koçman Vocational School of Muğla University in 1997, in Izmir Vocational School of Dokuz Eylul University. Her jewellery interest having begun in her childhood; she began her first jewellery making in 1989 with Güner Usta whom she met in Gem Mineralogy Stone Studio.

After completing her apprenticeship education there, she practised wax moulds of jewellery designs with Mr. Türkiz in Türkiz Jewellery where she began as an intern and she completed semiskilled phase by learning jewellery production techniques. Thinking that craftsmanship phase would continue till the end of her life, Müjgan Eroğlu got Jewel CAD - computer assisted jewellery design training, saying that its necessary to keep up with contemporary technologies and she teaches these techniques to her students.

Since 1994 she has attended both solo and group exhibitions with her jewellery and accessory works and has exhibited her students' practices in many exhibition halls and fairs since 1997.

LUNA: Necklace practice made by seashells, red coral, mother of pearl and red sand beads stitched on shuttle lace with suture technique.

THE SEPARATES: They were adapted on titanium braid, prepared according to the finger loop form, by needling on lace. Silver was used in band parts.

contact details:
mujgan.emre@deu.edu.tr
meroglu02@gmail.com

left
Luna
right
Hena party

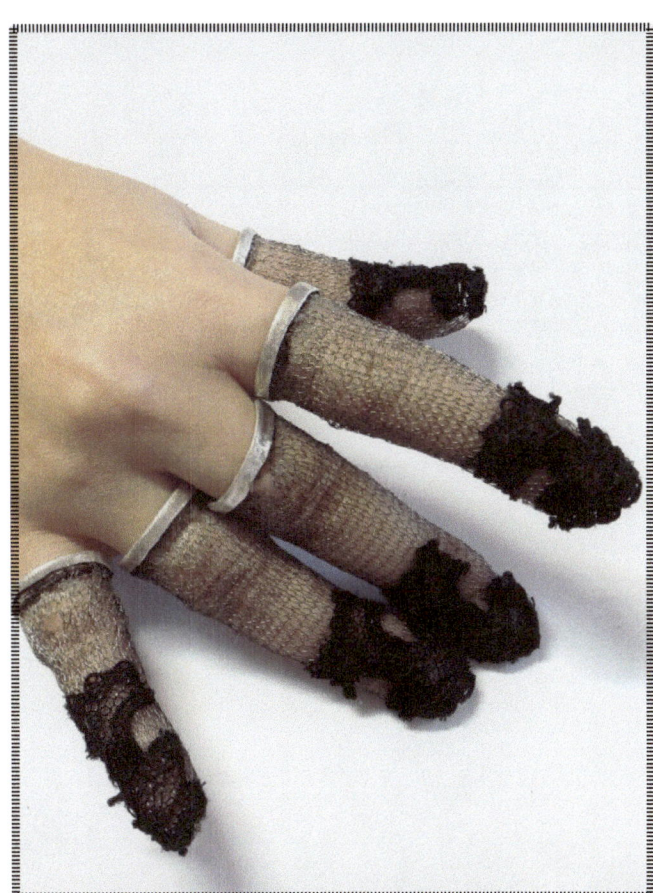
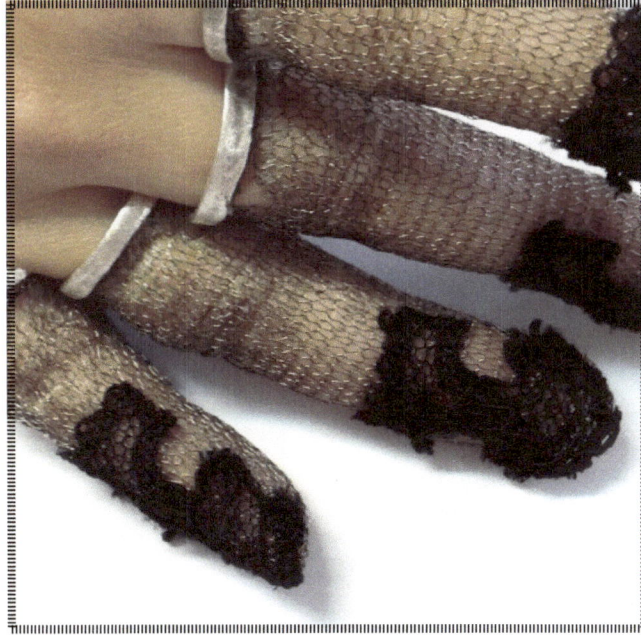

mustafa kula

Mustafa Kula completed his art/ design education B.A. and M.A. on fashion and accessory design field at Dokuz Eylül University Faculty of Fine Arts, Textile Department, Fashion Accessory Design Program. He has won many design degrees such as; JTR-Jewellery Design Contest, First Place(2014); Florida "ArtServe-Art Bravo" (2012) Honorable Mention; "International Shibori Symposium" - "New Beat" (2012) Silver Award; "World Gold Council- Golden Jewellery Design Contest" (2001); 2./3. Creative Shoes Design Contests (1999-2001); "4.Deri'signer" leather Garment design Contest (2003). His artistic work has been presented in; 25th International Textile Art Exhibition, Graz-Austria (2009); 7th International Shibori Symposium, Paris-France (2008); Fiber Art Exhibiton "Wearable/ Not Wearable" Ayşe Takı Gallery, İstanbul (2007); "Visions İn Textile" International Textile Art Exhibition, İzmir (2005). He is workin as full time Lecturer and as a free lance designer at Dokuz Eylül University Faculty of Fine Arts, Textile & Fashion Design Department

I used silk, leather and denim in my works as materials. I softened the stiff structure using flower modules on leather cuffs. For the neck piece, I coloured silk fabric with shibori technique and applied silk on denim.

contact details:
mustafa.kula@deu.edu.tr

top
Macig
bottom
Poison

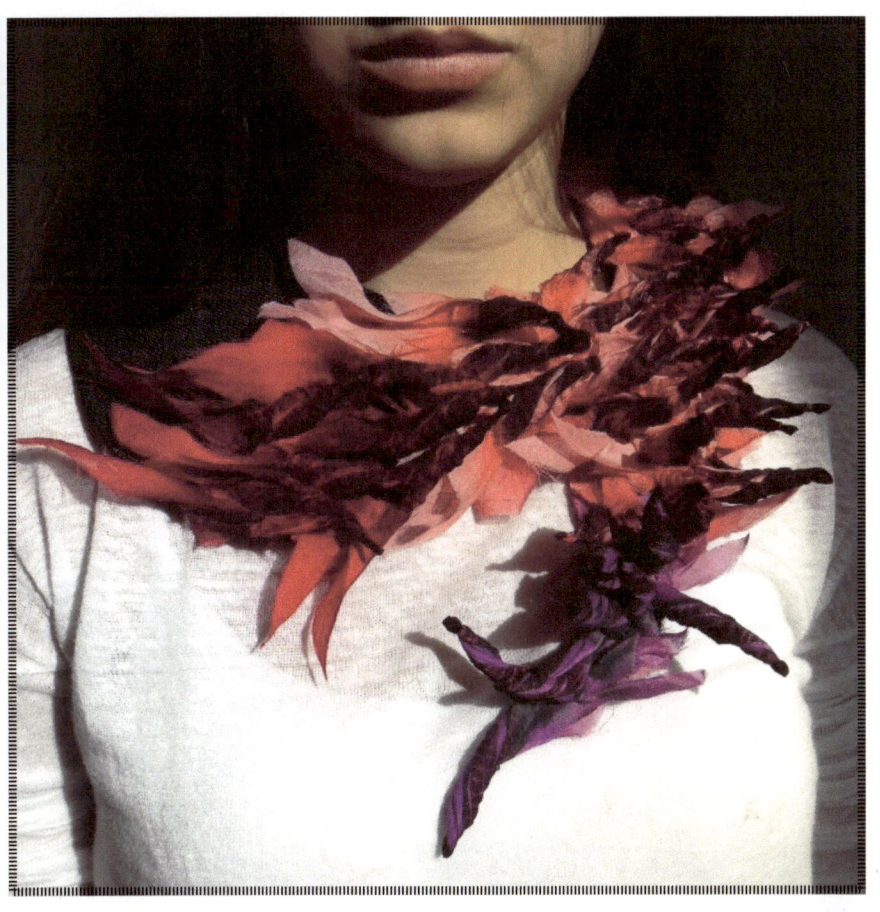
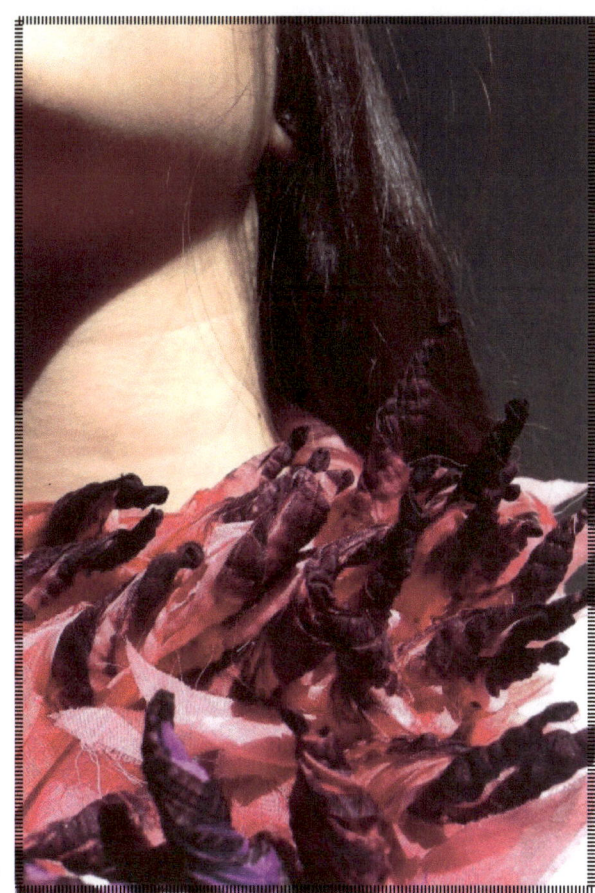
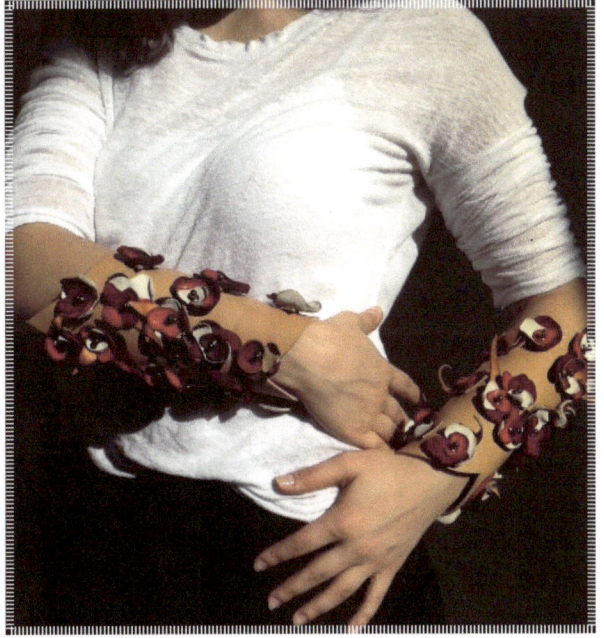
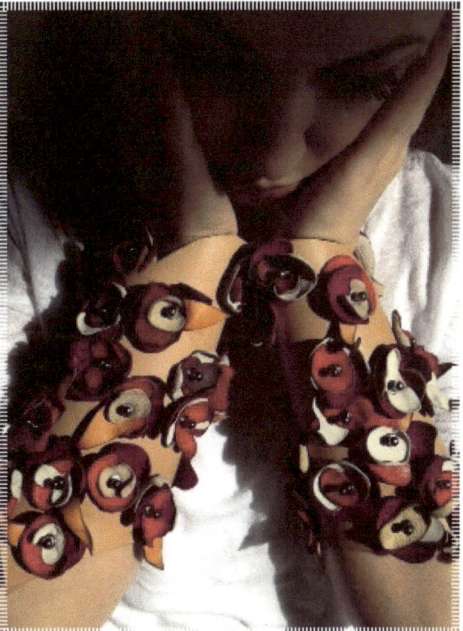
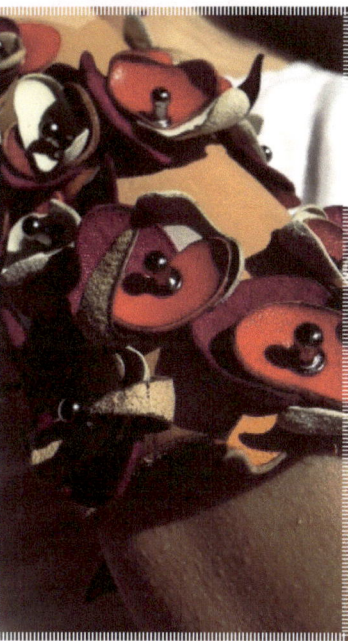

natasha morris

Natasha Morris is a metalsmith who received her BFA in Fine Arts with a minor in Entrepreneurship from Tufts University and the School of Museum of Fine Arts, Boston. She currently resides and maintains a studio in Miami, Florida, where she designs and creates jewelry and body adornment founded on ideas of preciousness and irony. Her recent projects are greatly inspired by archetypes of jewelry, Cabinets of Curiosities, and the incorporation of coral as one of the elements in their execution.

With my work I aim to explore the traditional expectations of jewelry with the inclusion of comicality. Traditional jewelry is centered on the everlasting; through the use of gemstone like diamonds and sapphires along with precious metals including gold and silver. I attempt to question, challenge and contradict traditional jewelry themes of preciousness and body adornment. My recent collection entertains the idea of "jewelry about jewelry". A wearable jest that twists the expectations and adds irony to the form of traditional jewelry.

contact details:
natashaalessandra.com
conceptualcarats.tumblr.com
natasha.morris415@gmail.com

An Ocular Romance

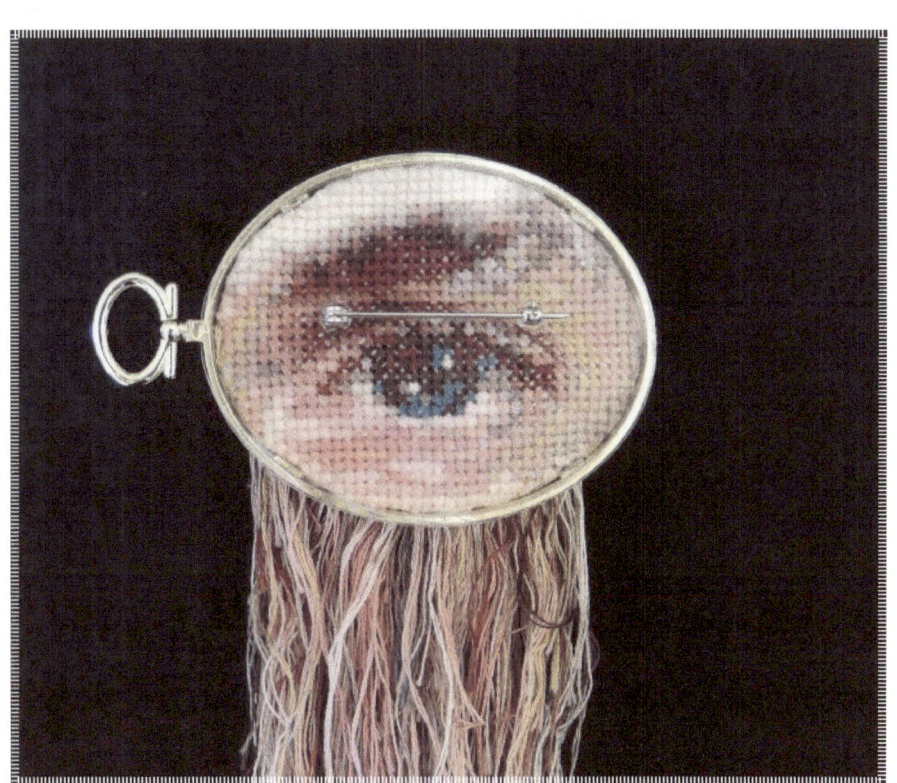
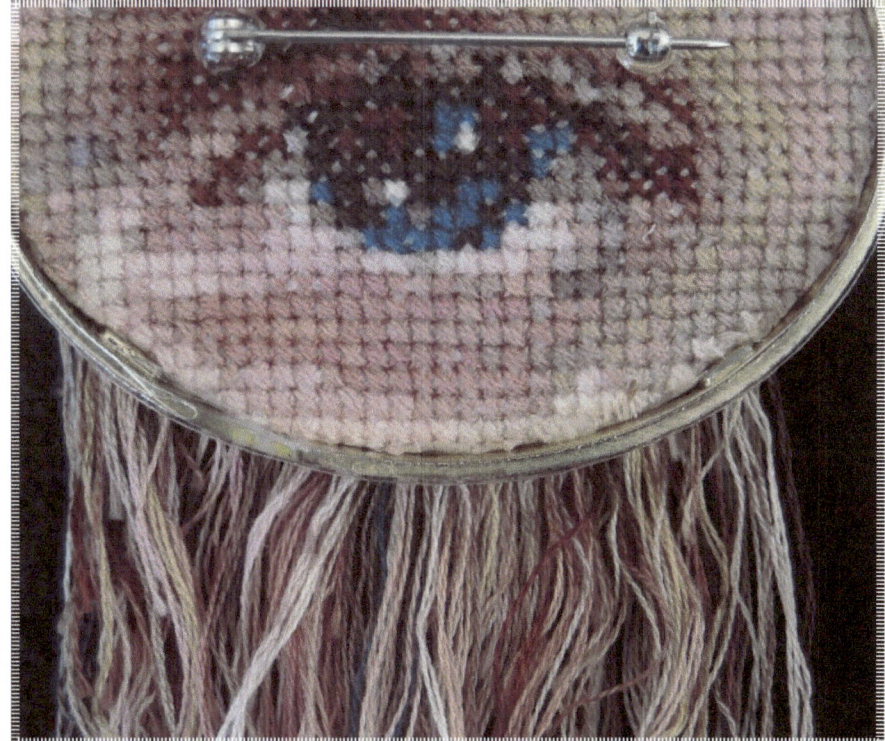

neşem ertan ayata

Born in İzmir, Turkiye; 1979. Had her BA. degree in Dokuz Eylül University, Faculty of Fine Arts; Textile and Fashion Design Department, Fashion Accessories Design Major; and her Master of Arts and Proficiency in Fine Arts degrees in Dokuz Eylül University, Institute of Fine Arts; Textile and Fashion Design Major. She's specialized on contemporary jewellery and keeps on practicing jewellery and experiments on sculptural forms in 3D. Uses jewellery making techniques, saddlery techniques, 3D modeling and textile techniques including: felting, papermaking, weaving and own techniques. Interested in and has researches on contemporary jewellery, its design and production techniques, non-conventional jewellery materials, body jewellery, fiber art and wearable art.

She lectures in DEU. Fashion Accessories Design Major as an Assistant Professor. She took part in several national and international art exhibitions such as "Miniartextil" in Como- Italy, "3rd International Triennal for Miniature- Textiles" in Szombathely- Hungary, "Wearable Expressions" in California- USA, "ITS#FIVE International Talent Support- Accessories" in Trieste- ITALY; had received design awards.

I think of jewellery as a medium of artistic expression. In my jewellery works, I combine unconventional jewellery materials and techniques with the conventional ones in order to create unique pieces.

contact details:
nesemertan@gmail.com

left top to bottom
Africa
Blue animal
right
R2

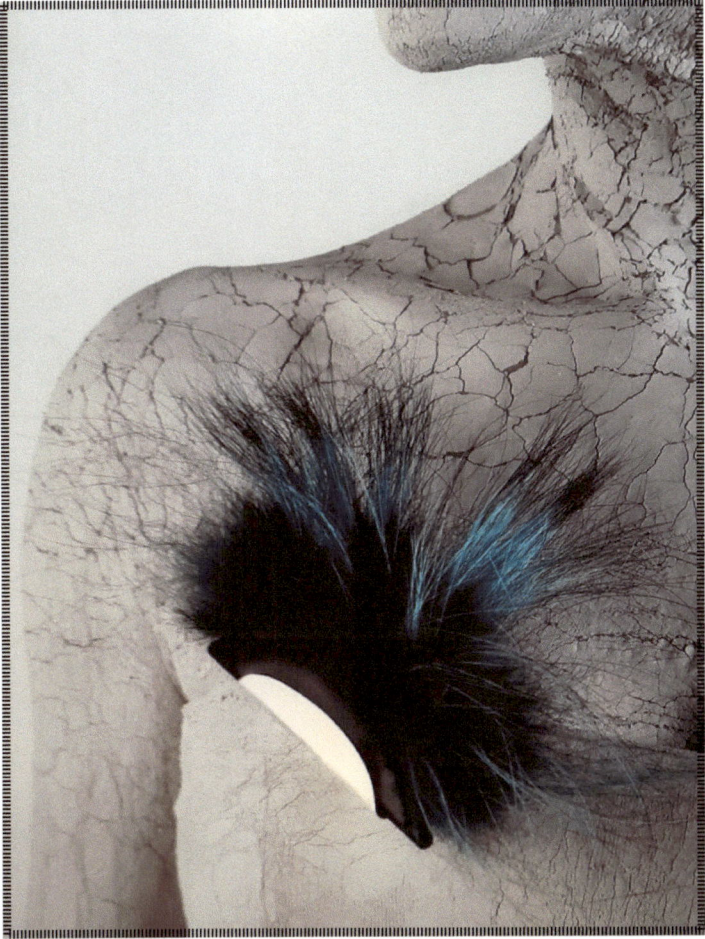

oylum öktem işözen

Oylum Öktem İşözen has been graduated from Marmara University, Fine Arts Faculty, Fashion Design Department. After completing her MA in Mimar Sinan University, she has been titled PhD with "The Outlook Of The Evalution of Value Trends Since The Republican Era from Fashion Perspective" thesis.

After working as design executive with the major brands in the fashion industry, she took part as a manager, art director and fashion design department chairman in the establishment of the Istanbul Fashion Academy, which is a collaborative European Union project with The Istanbul Textile Exporters Association and Fashion Faculty of the University of London. She has specialized in design education at London College of Fashion and has been teaching in this area in Bilgi Universty in İstanbul.

The artist who has directed many exhibitions as a curator, in Turkey and in the international arena, she has invited to Europe Skills and World Skills contests, as the country jury.

The artist, who has ongoing multi-disciplinary studies within the branch of sculpture, also produces personal exhibitions and commission works.

Oylum Oktem Isozen, who is the art director of Sculpture Tankut Oktem House Museum and Ottoman Clothing Collections House Museum, has published books on fashion and sculpture.

contact details:
oylumoktemisozen.com
oylumoisozen@gmail.com

top left to right
Flower point lace
Aegean point lace
bottom
Butterfly symphony

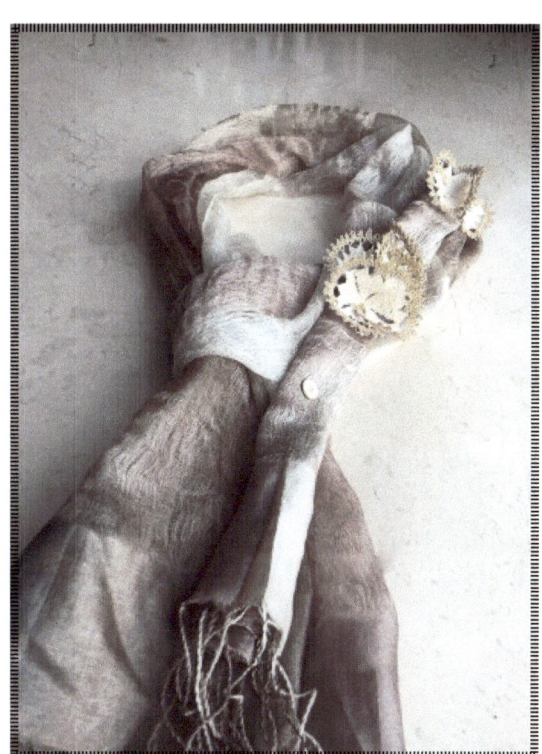
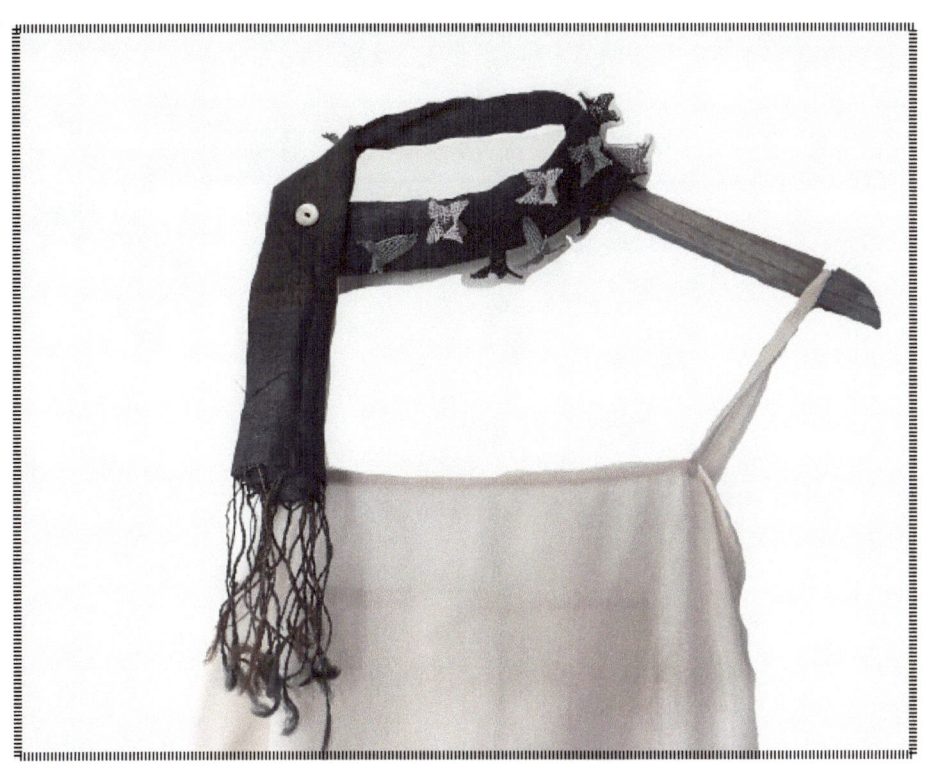

özge erbilen yalçin

Born in Izmir/Turkey in 1977. She completed undergraduate and master's academic degree at Dokuz Eylul University Faculty of Fine Arts Textile Department. In 2009 she was appointed as a research assistant. She completed PhD academic degree at same department in 2015. She won merit pays and a championship award participated in several design competitions. She participated in certain group and mixed exhibitions domestic and abroad.

The time goes by but memories remain…
Memories on the human mind which connects the past to the future are the most precious treasures. Time travel becomes possible by means of these memories. In this study, concepts of the past and the future were emphasized by the two different forms of shaped surface and by the combination of naturel and synthetic materials.

contact details:
ozgeerbilen@gmail.com

Time travel

pelin demirtas dikmen

She was born in Diyarbakır, 1970. Completed Bachelor and Master's Degree in Textile and Fashion Design Department of DEU Faculty of Fine Arts in Fashion Accessories Design Program. In addition to the classes she lectures at the Design of Fashion Accessories major of textile Department, she has made researches, published articles and made presentations in symposiums, seminars or panels on "Sociological Structure and Accessory", "Culture of Accessory", "The History of Accessory and Jewelry", "Product Design in Accessory and Jewelry", "Accessories of Antiquity", "Different Material in Accessories and Jewelry Production". In her works, she focused on the concept of wearable art and sculptural forms. Currently, she works as a Lecturer at DEU Faculty of Fine Arts, Textile and Fashion Design Department.

Attended national and international juried exhibitions of Wearable art and fiber art; and took part in
- 9th International Shibori Symposium, Conpemporary Art of Shibori Hong Kong-2014
- Contemporary Textile Art Exhibition Miniartextil, Museo Civico Archeolgico " Polo Giovio" Como, İtaly ,2013
- Suave 5 International Juried Textile Accesories Triennaial Madrid / Spain 2013
- Textile Triennile and Contemporary Art, Miniature textile Triennale, Hungary 2012
- Suave 4, Fashion Accessory Design Competition, Spanish Cultural Centre, Costa Rica / Spain, 2010
- Exposition Miniartextil a Montrouge Montrouge- Fransa 2010
- IV. International Turkısh Culture And Art Actıvıty, Cairo Egypt, 2009
- Fiber Art"; Egeart 2009, Izmir, TURKEY 2009
- Contemporary Textile Art Exhibition Miniartextil, Museo Civico Archeolgico " Polo Giovio" Como, İtaly ,2009
- International de Complementos tekstiles Suave-3 Toledo, Spain, Sala Mezquita Fundacion Mezquita de Las 2009
- Soft 3, Fashion Accessory Design Competition, Teressa Barcelona, Spain ,2008

In my textile jewelleries, I designated needleworks as main material and supported them with side materials to put them forward. I directed my works combining needlework and metal, needlework and vegetal leather.

contact details:
pelin.demirtas@deu.edu.tr

top
Spring
bottom
Passion

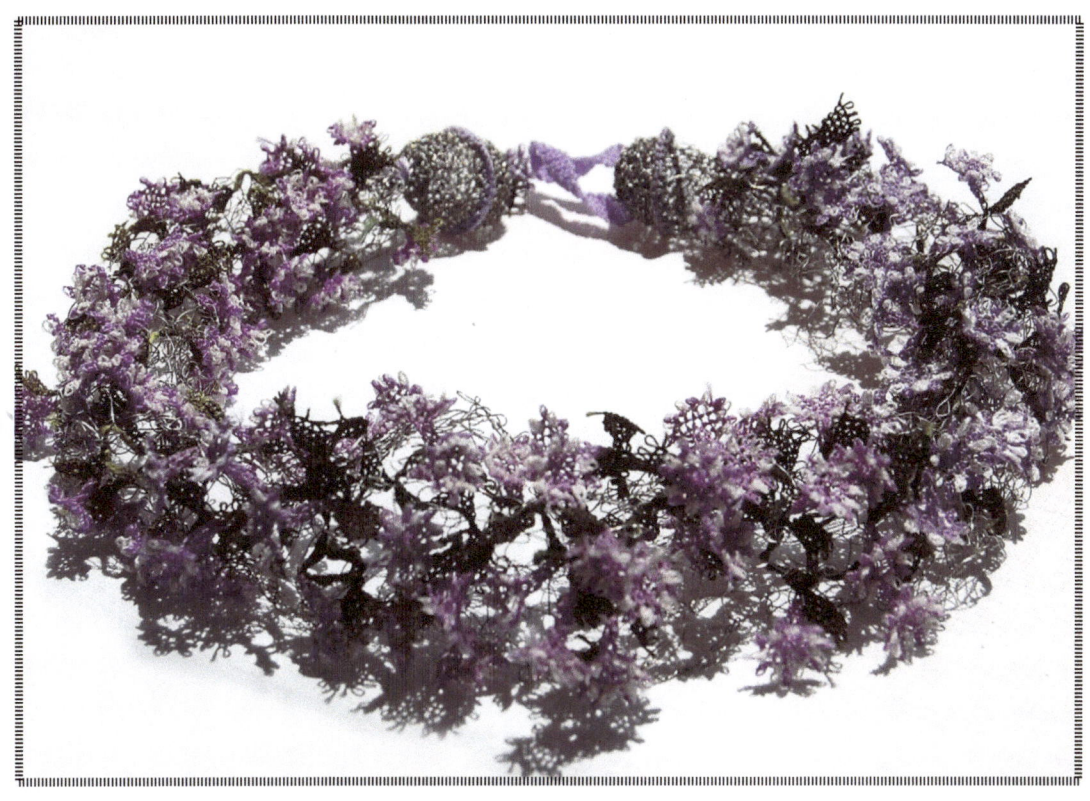
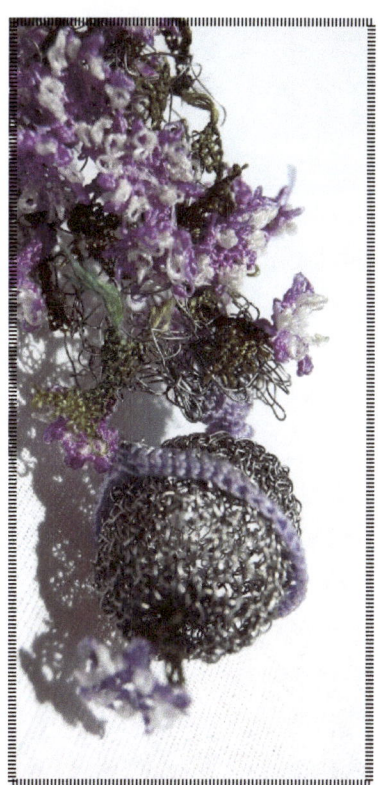
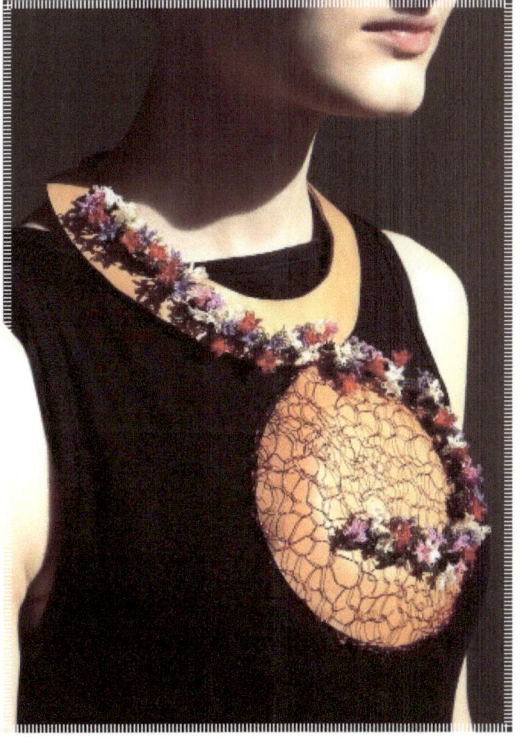
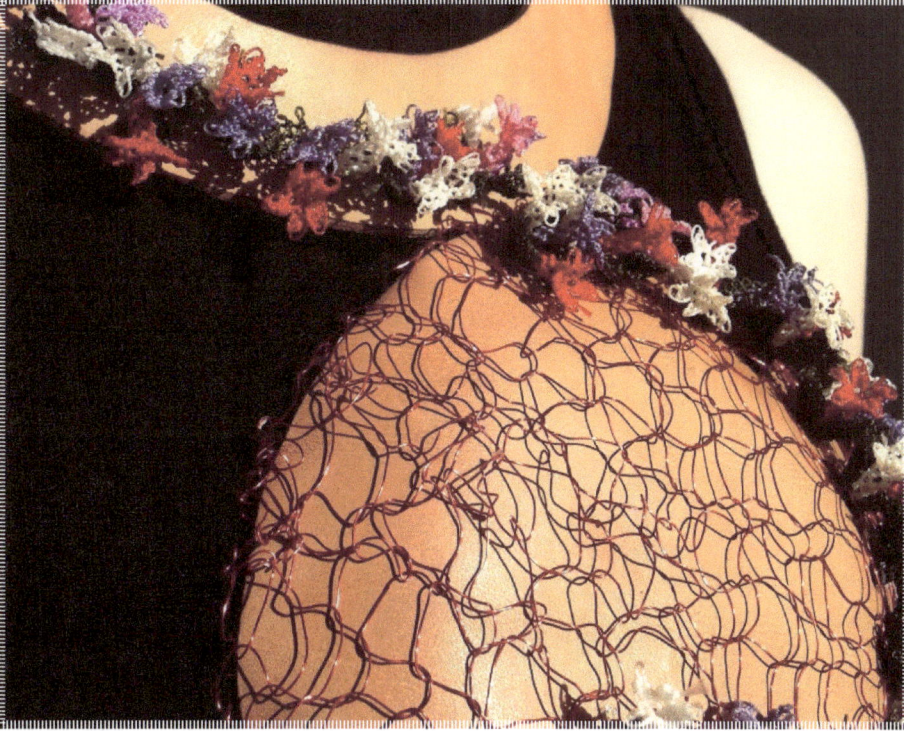

penelope parx

contact details:
penelopeparx@gmail.com

left
Soft necklace
right
Penelope bracelet

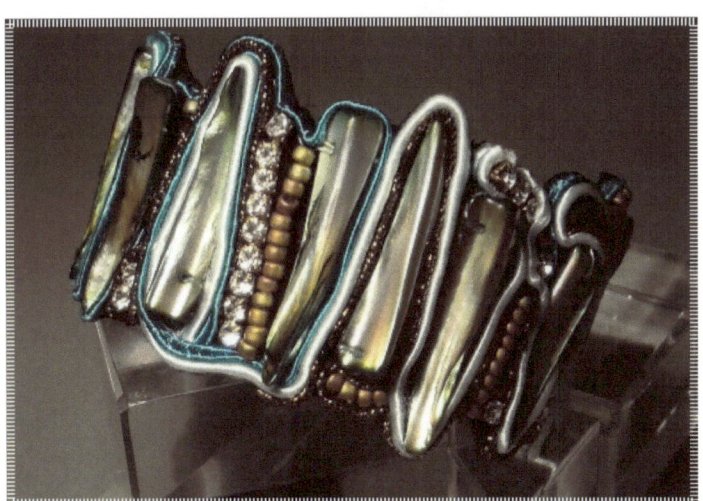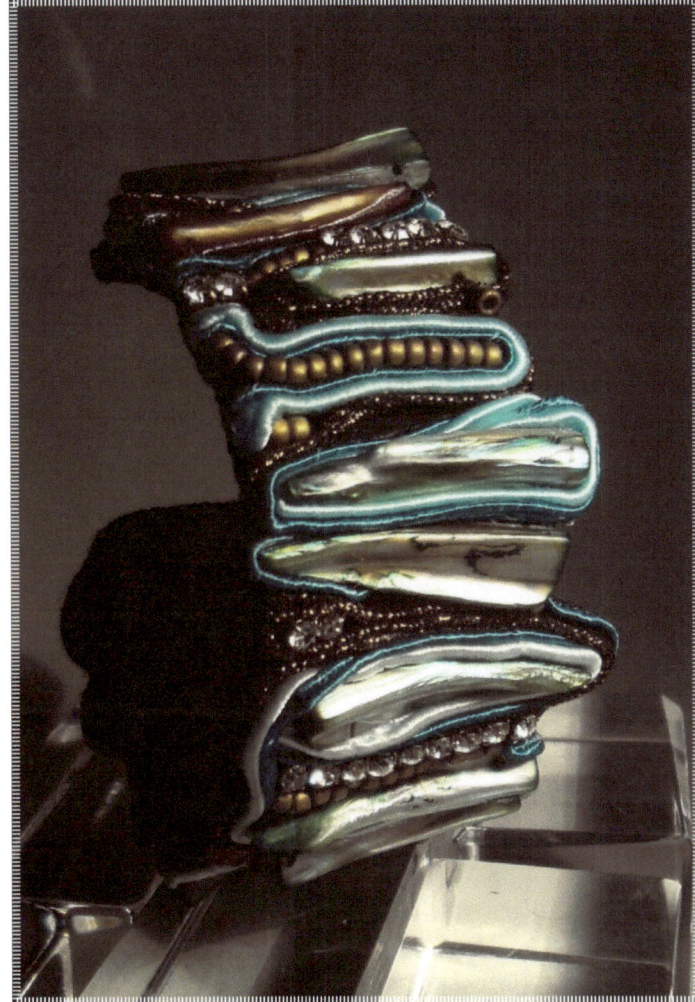

phoebe williams

Phoebe Williams is an undergraduate architecture student. During her art lessons she experimented with various materials. She works with yarn, fabric, leather and various craft techniques, exploring the potential of each material.

The power of thread is the key to the world of textiles. I have also great respect for paper.
Paper and fabric are everywhere and they have been telling stories for centuries.

contact details:
grlsunshine16@gmail.com

top
Joey
bottom left to right
Nicki
Kira

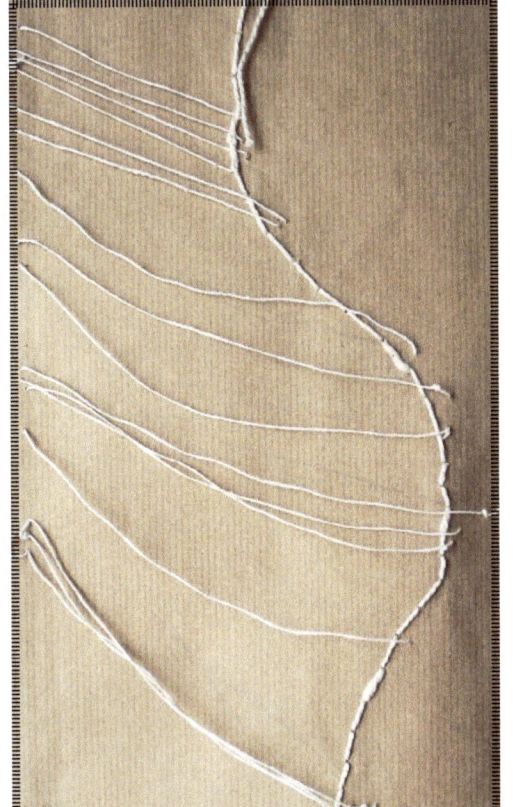
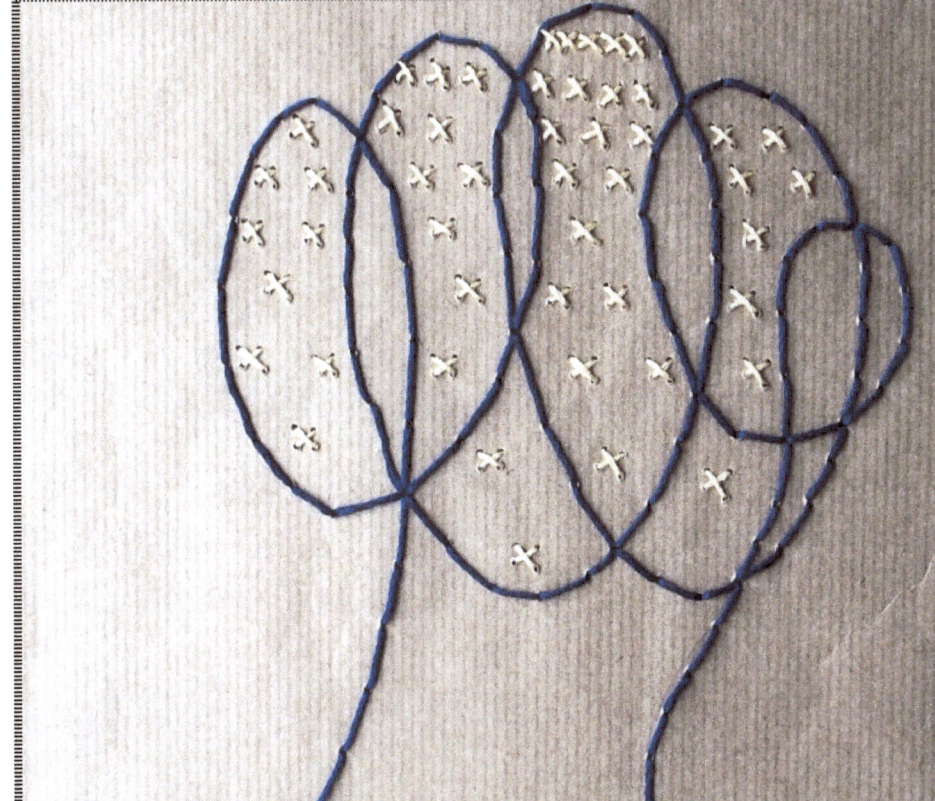

piotr pandyra

Born in 1981. In 2003 he graduated from the School of Art and Fashion Design in Krakow. In the years 2003/2009 he studied his artistic education in the arts at the Faculty of Arts Pedagogical University in Krakow. He is currently a PhD student at the Faculty of Arts at his alma mater.
Selected exhibitions:
2015
Expressionism, over and over again, solo exhibition, 30.10 - 29.11. 2015 Nuremberg House Gallery, Kraków (Poland)
XI International Air Plein - Spatial forms of wicker, 16.06-26.06. 2015 Poleski Art Centre, Lódź (Poland)
Stops on the trip. Sewing images. "16.05-30.06.2015 solo exhibition during the Night of the Museums, the Museum Workshop-JI Kraszewski, Poznań (Poland)
On the walk with the expressionists, 10.04-12.05. 2015 solo exhibition, Gallery 526 Poleski Art Centre, Lódź (Poland)
2014
Le petit est beau. Jewellery made of paper. - The International Exhibition Museum of Japanese Art and Technology Manggha, Kraków 2014(Poland)

My jewellery pieces function both as wearable pieces of
body adornment and as sculptural objects off the body.

contact details:
pandyra.piotr@gmail.com

Ocean's secret

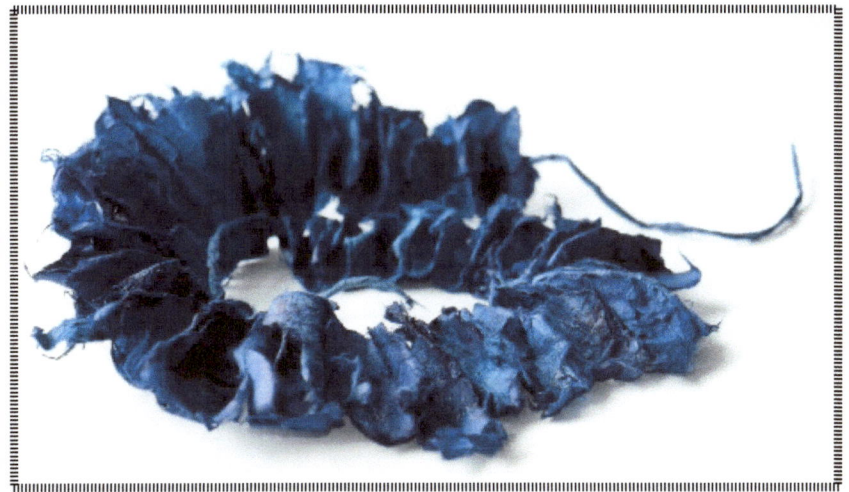
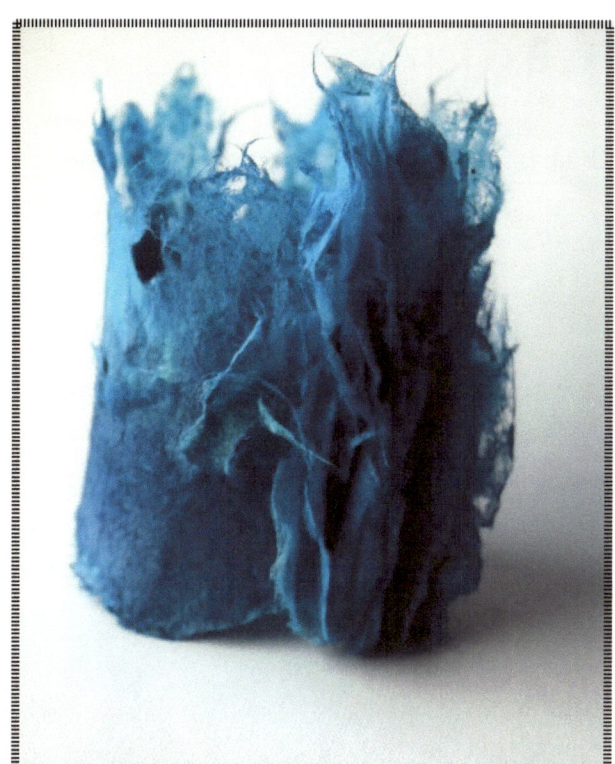
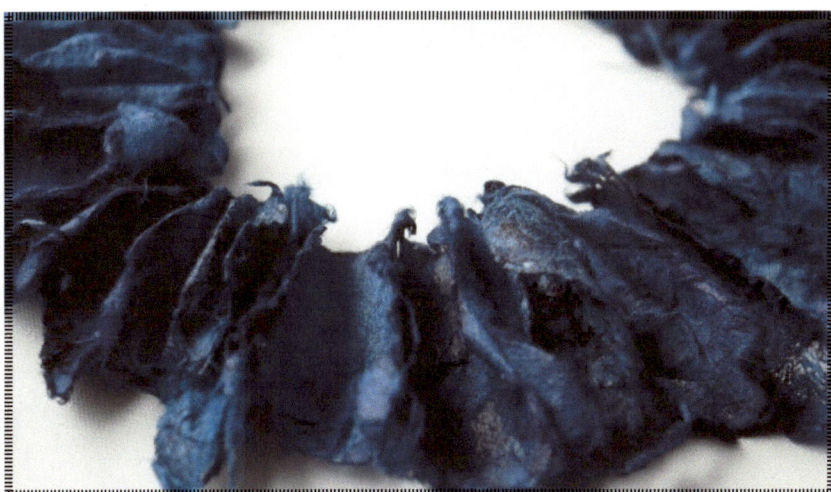
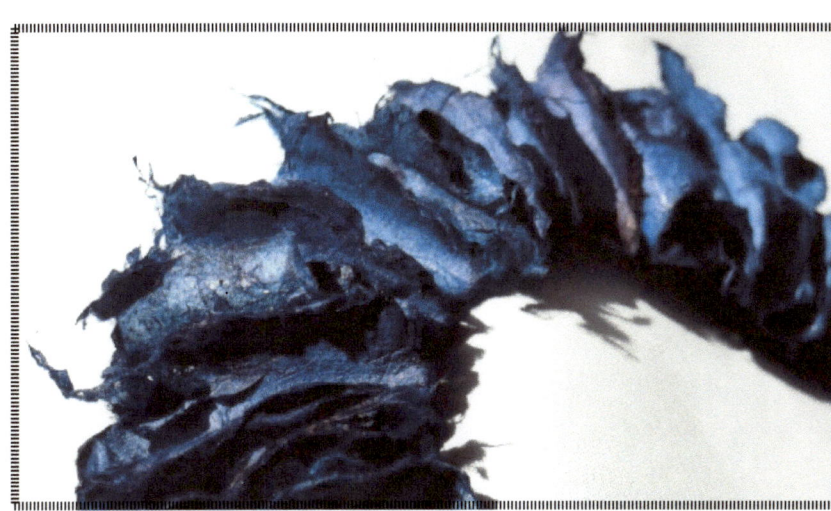
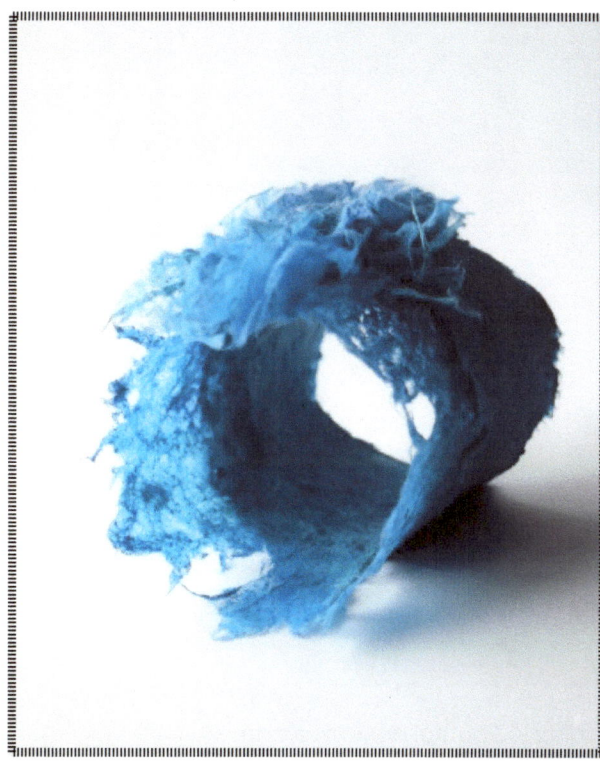

thalia sidi

She is a self taught craft artist from Thessaloniki.

Art is not a concept for it is not defined.
It is creation.
Anything you create is art, even if you think it's not. Even a thought can be considered art if it sparks something within you, me or anyone.
Thus the existence of art is firm evidence that there is magic in the world and not everything is all that humble.
You can create magic in any form! ... In the form that you wish.

contact details:
sidiropoulouthalia@yahoo.com

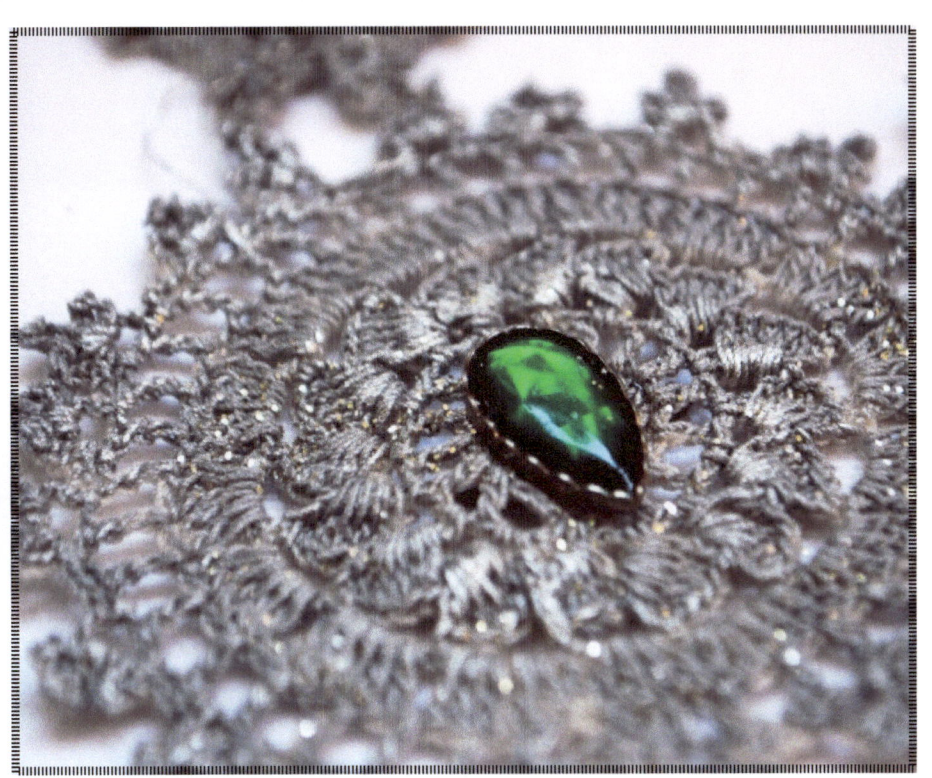
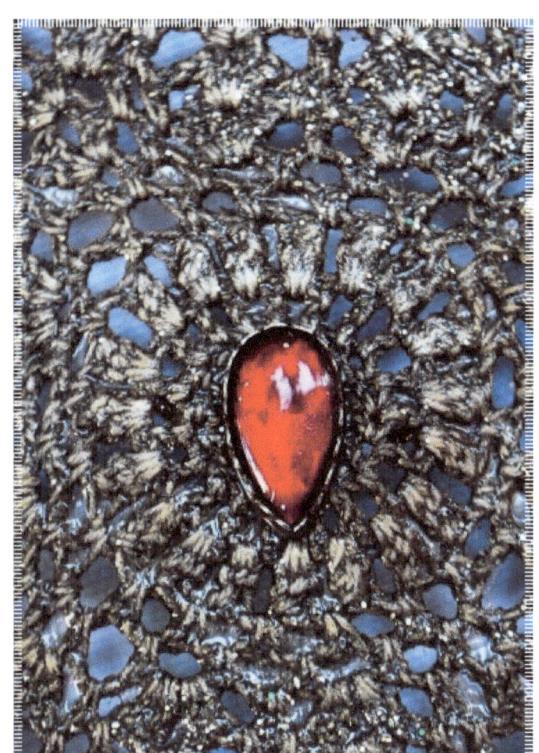
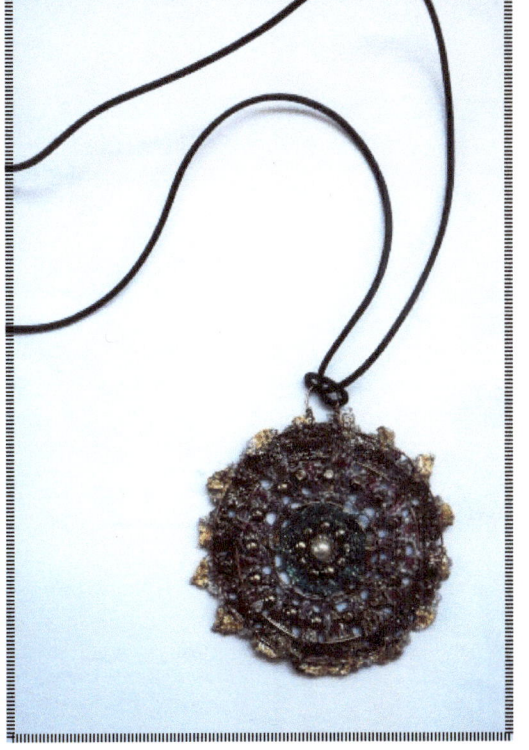
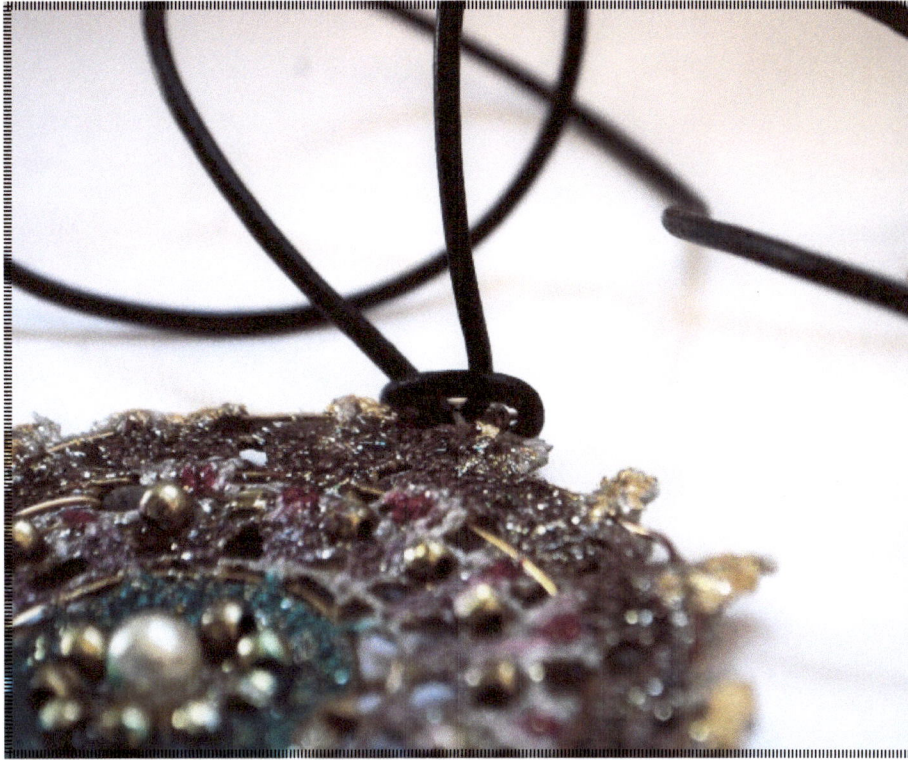

fotini xatzigeorgiou
foula papadopoulou
galini begalidou
iliana tzelepi
marina kappou
stamatia kouzeli

shooting jewellery

jewellery through the camera lens

When art aims towards art and draws inspiration from an idea and a pre-existing artistic practice, the creation evolves, takes off, soars. It bares itself onto a brand new universe. However, why to converse with another creator or to base your poem on someone else's lyrics?

Photography portrays a special version of reality, defined by the setting, the environment, the light and the shadows, all under the creator's watchful eye. Whatever stands out is transformed within the context of the aesthetic and the atmosphere suggested by the photographer. When an object has its own aesthetic value and artistic direction, things get creatively complicated and that requires a second artist's penetrative look.

In this case, it is the photographer's mission to revise and reshape the initial artistic writing through photographs.

The exhibition organized by AKTO College in Thessaloniki is based exactly on that idea of second level artistic reading, the jewellery's interpretation through the camera lens. The jewellery, inspired by techniques, textures and possibilities of fabric, adorns the body, the wall and intrudes into the photographic reality, in search of a new identity through the lens of AKTO College's young creators.

Follow the artistic journey from the jewellery to its photography, in the exhibition organized in the campus of AKTO College Thessaloniki.

Chrysa Xouveroudi
Art historian

fotini xatzigeorgiou

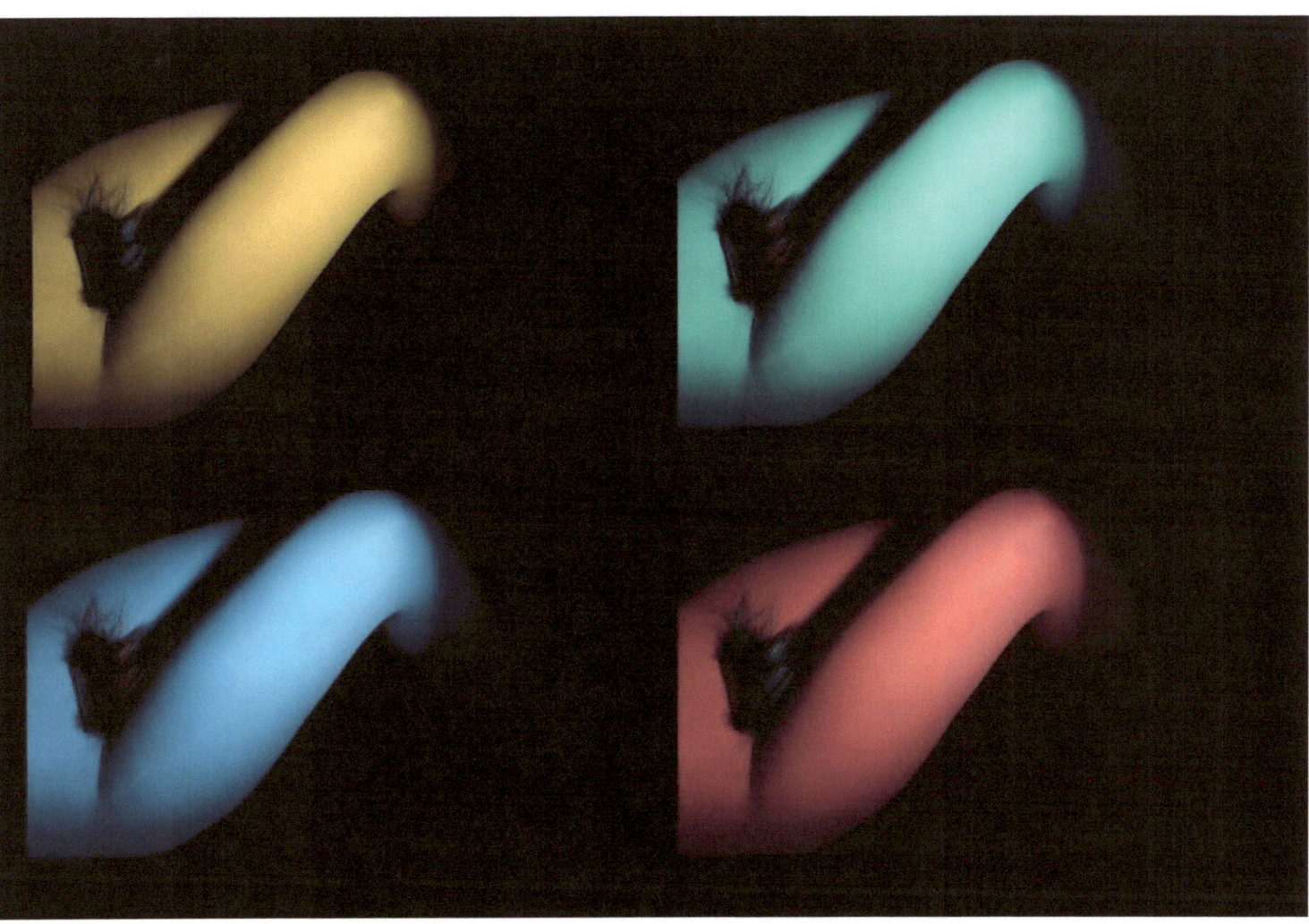

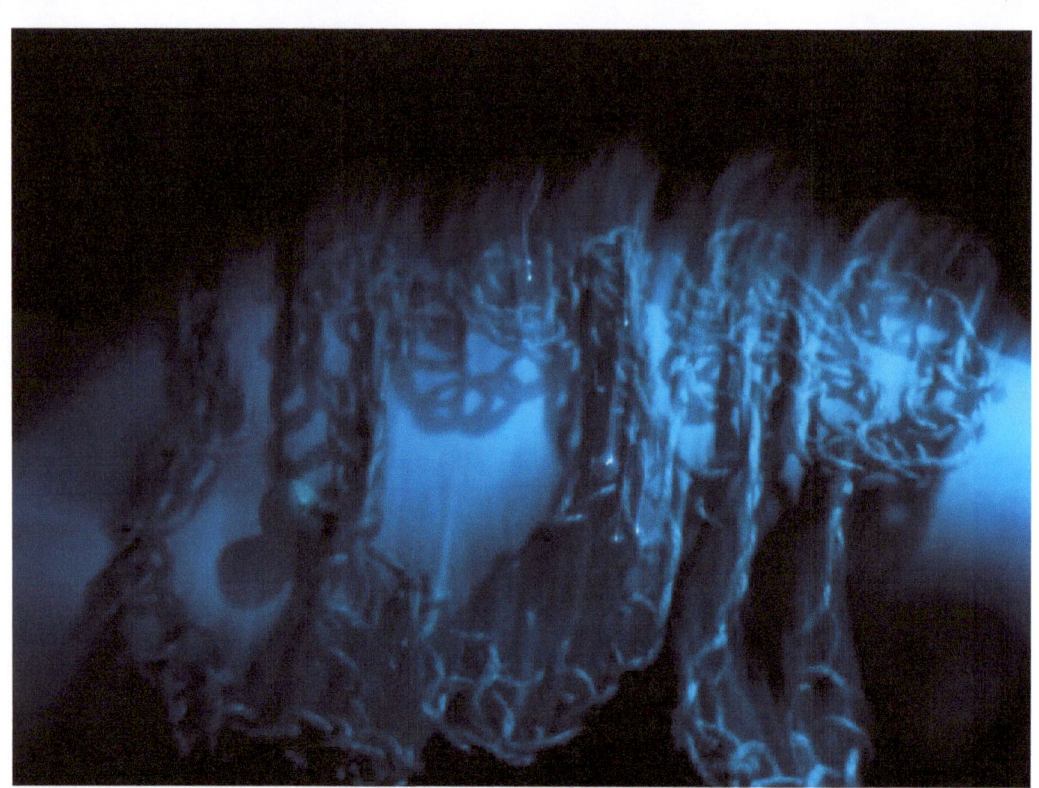
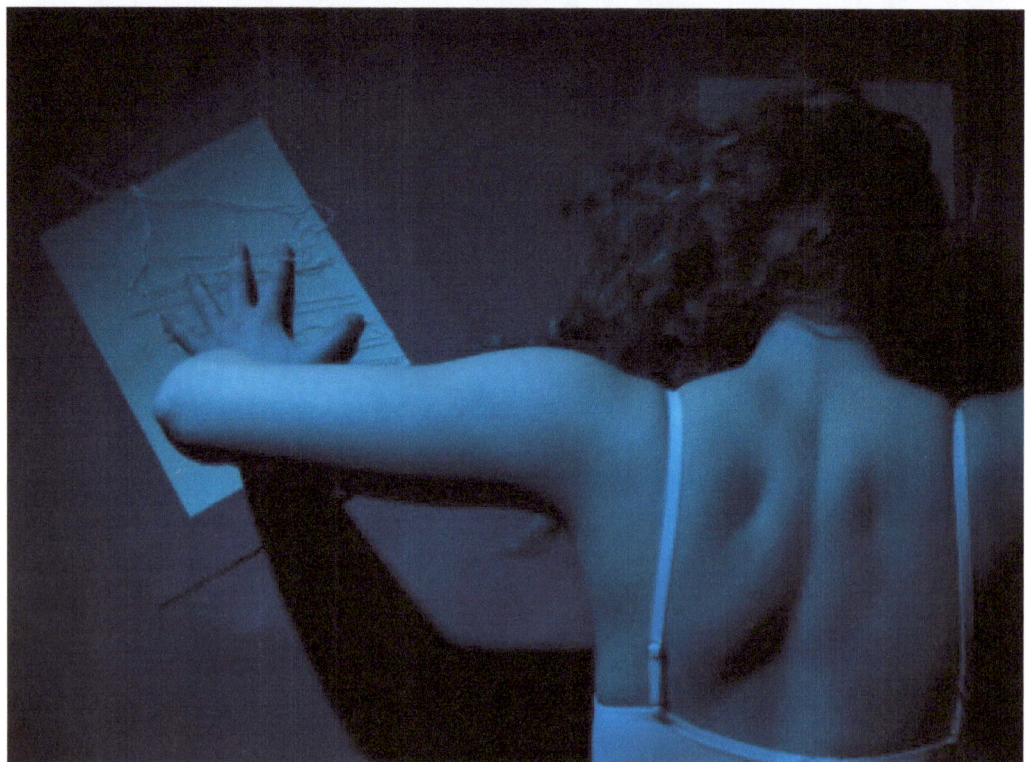

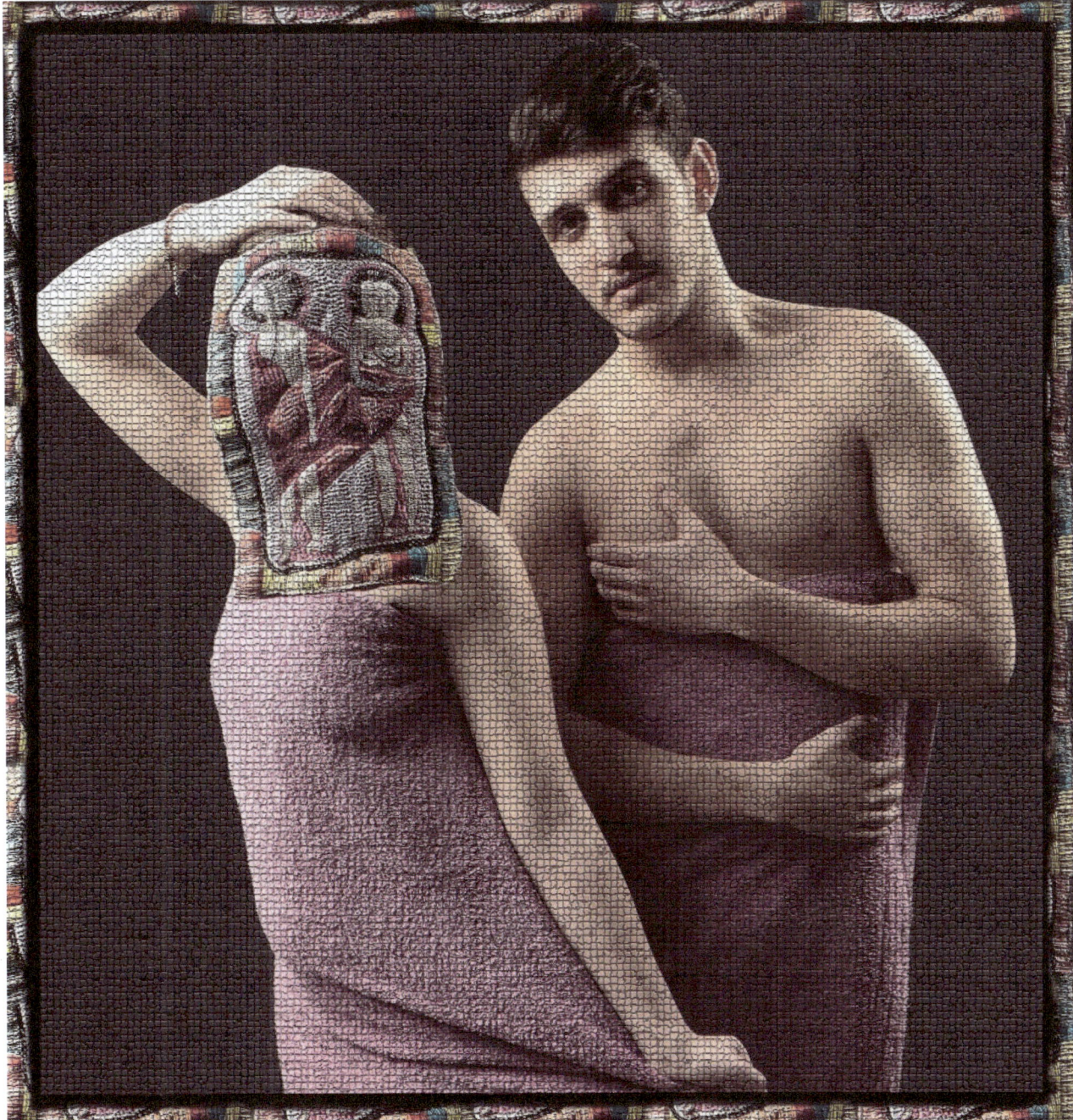

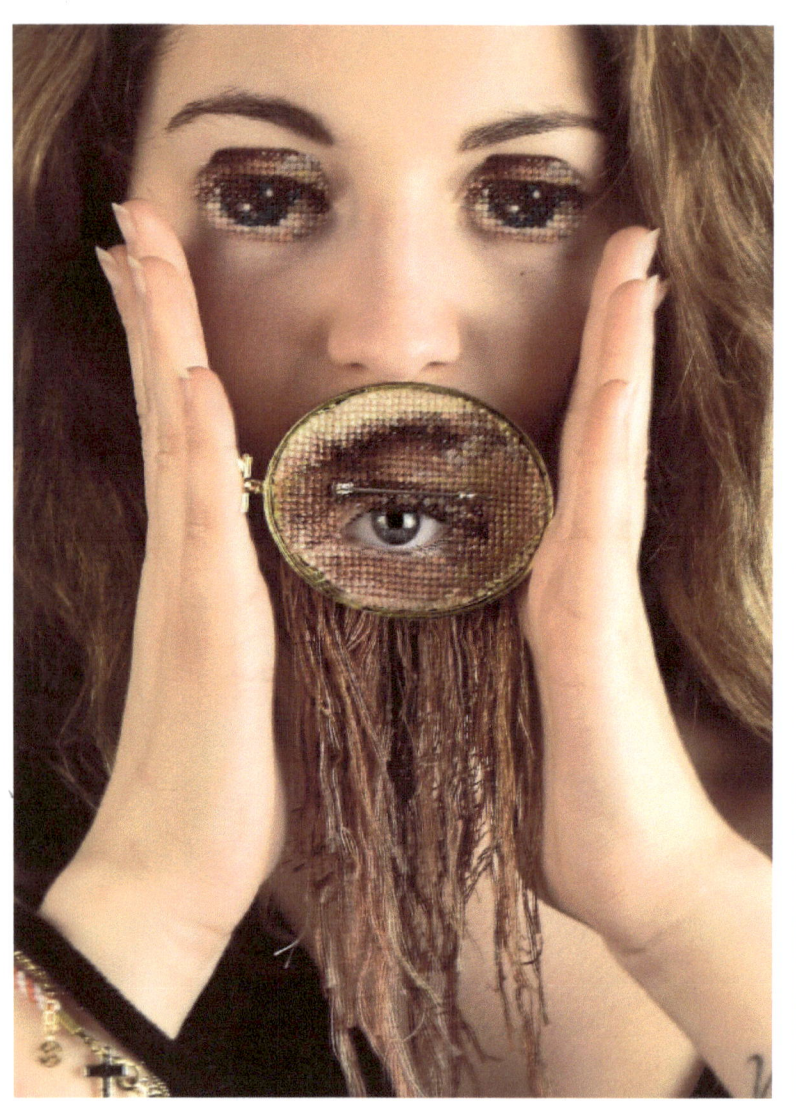
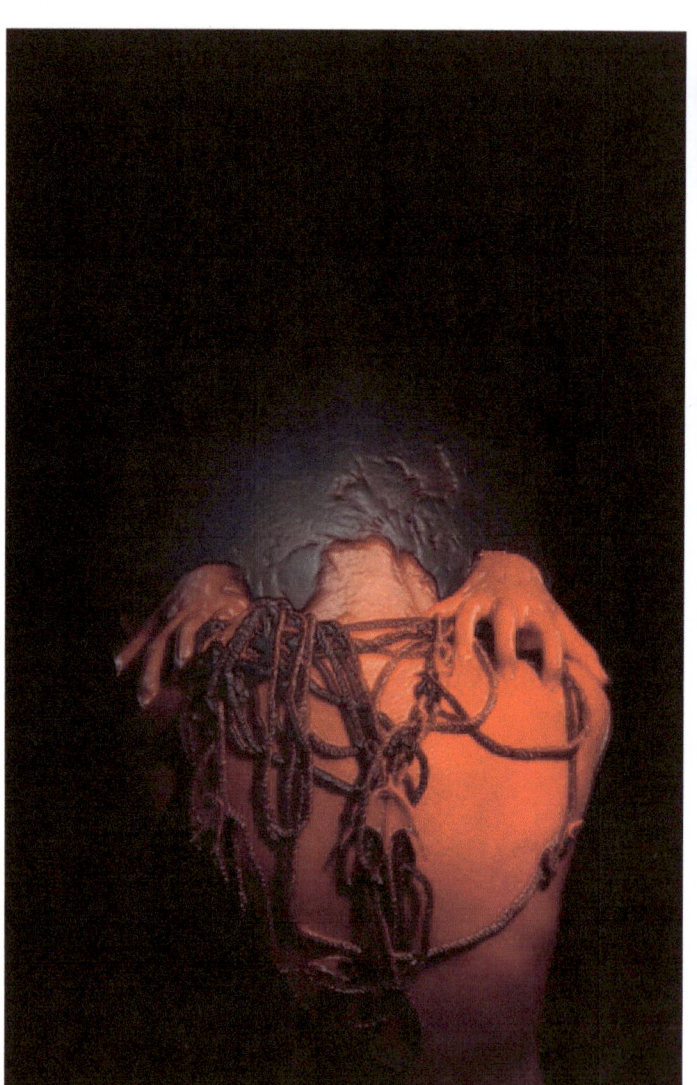

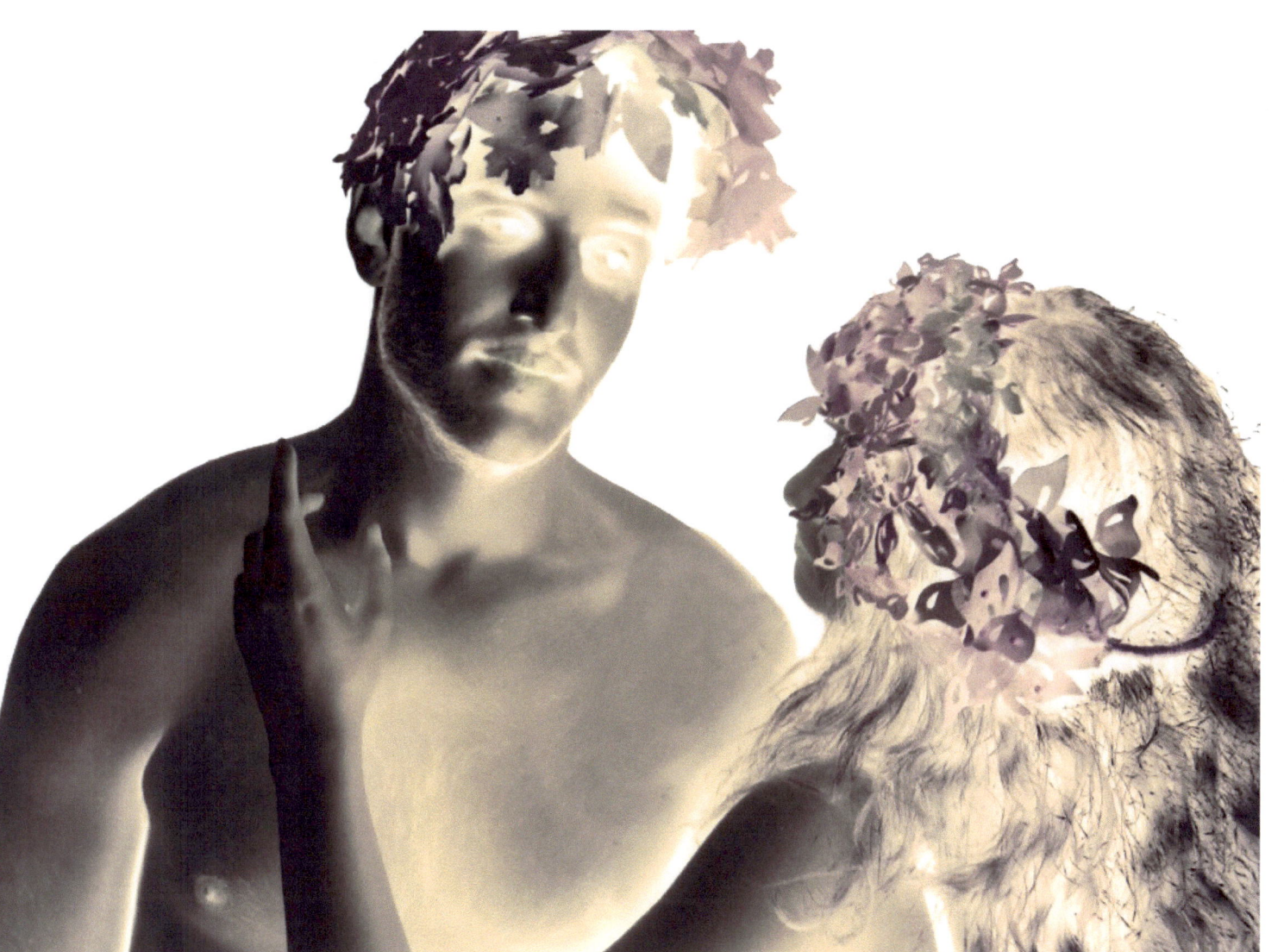

foula papadopoulou

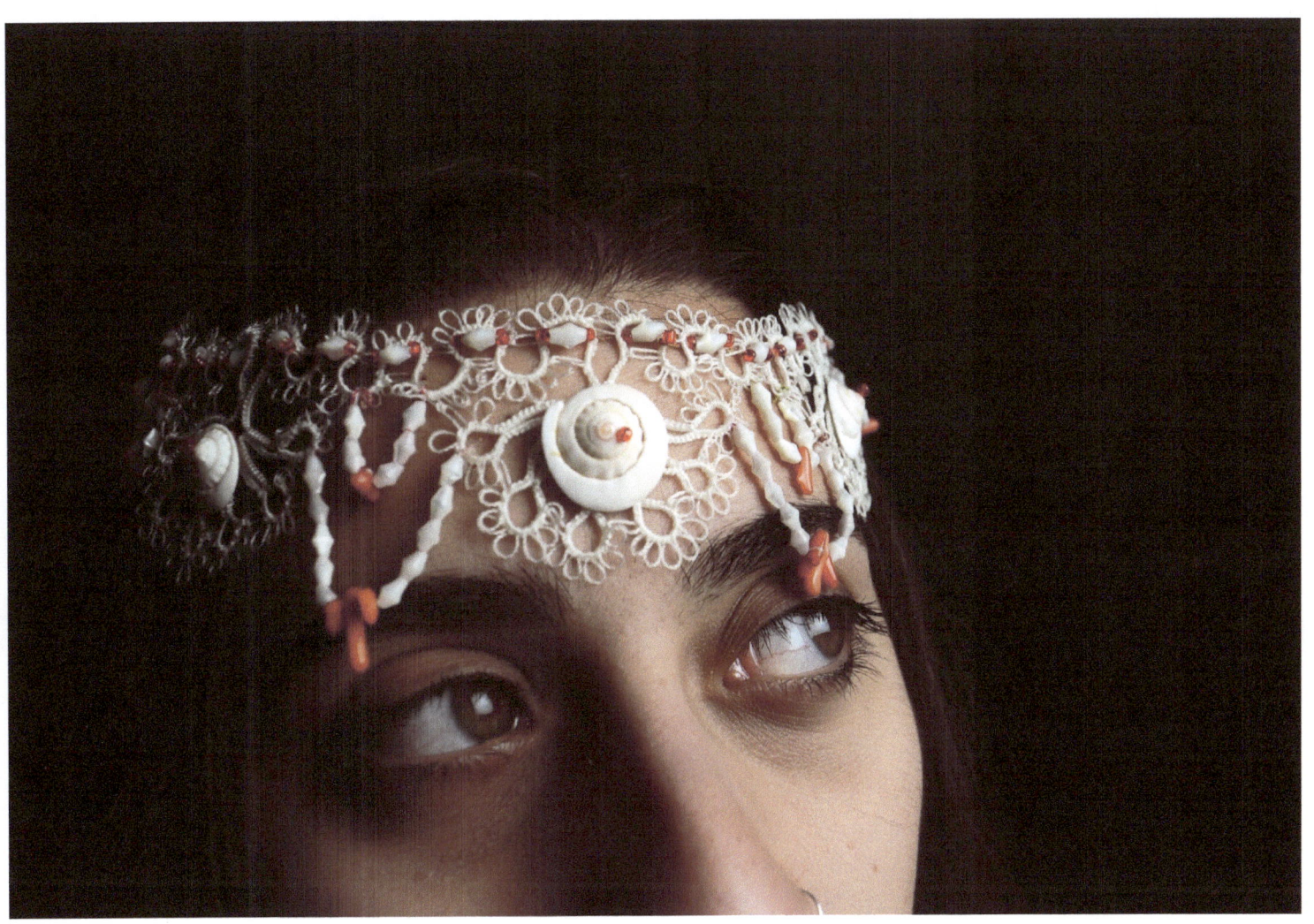

galini begalidou

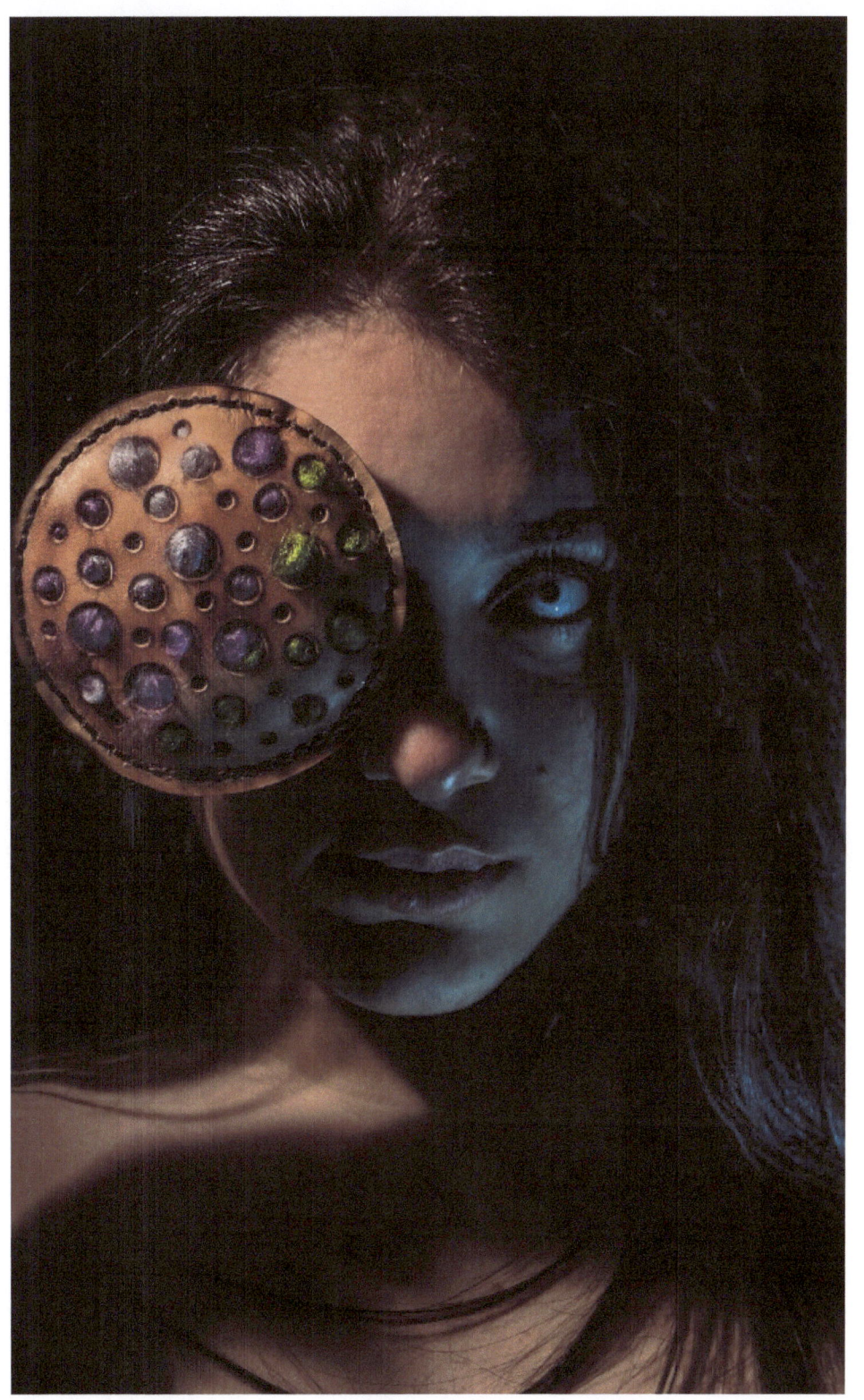

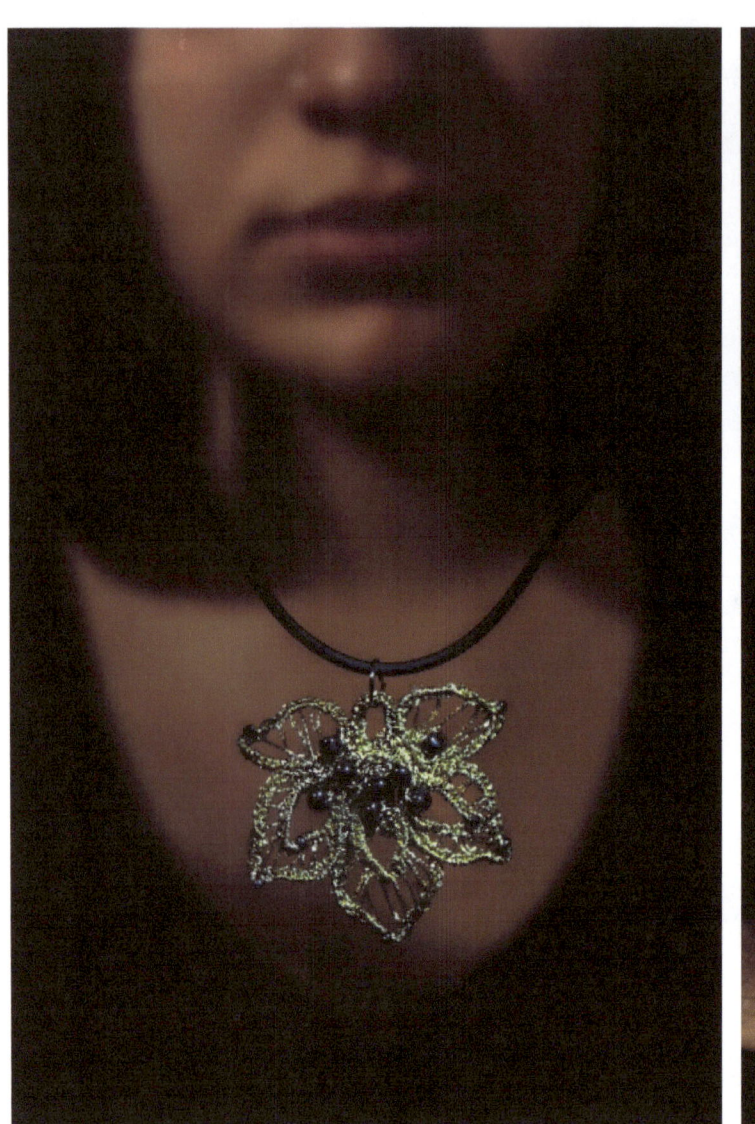
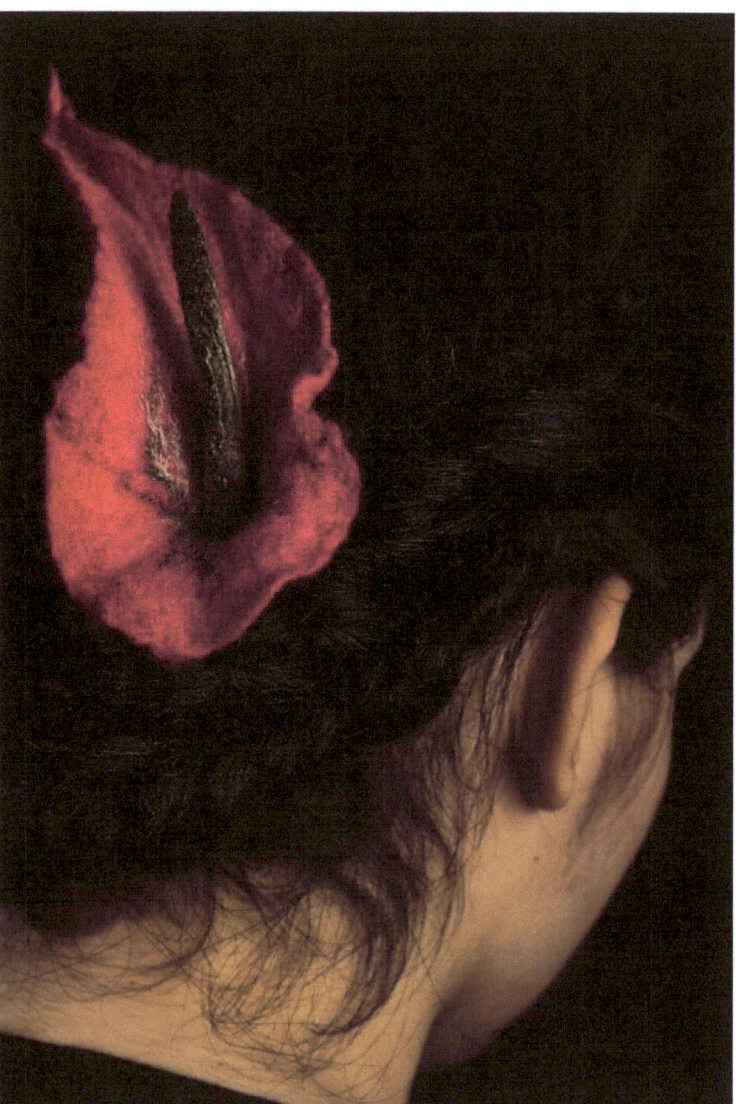

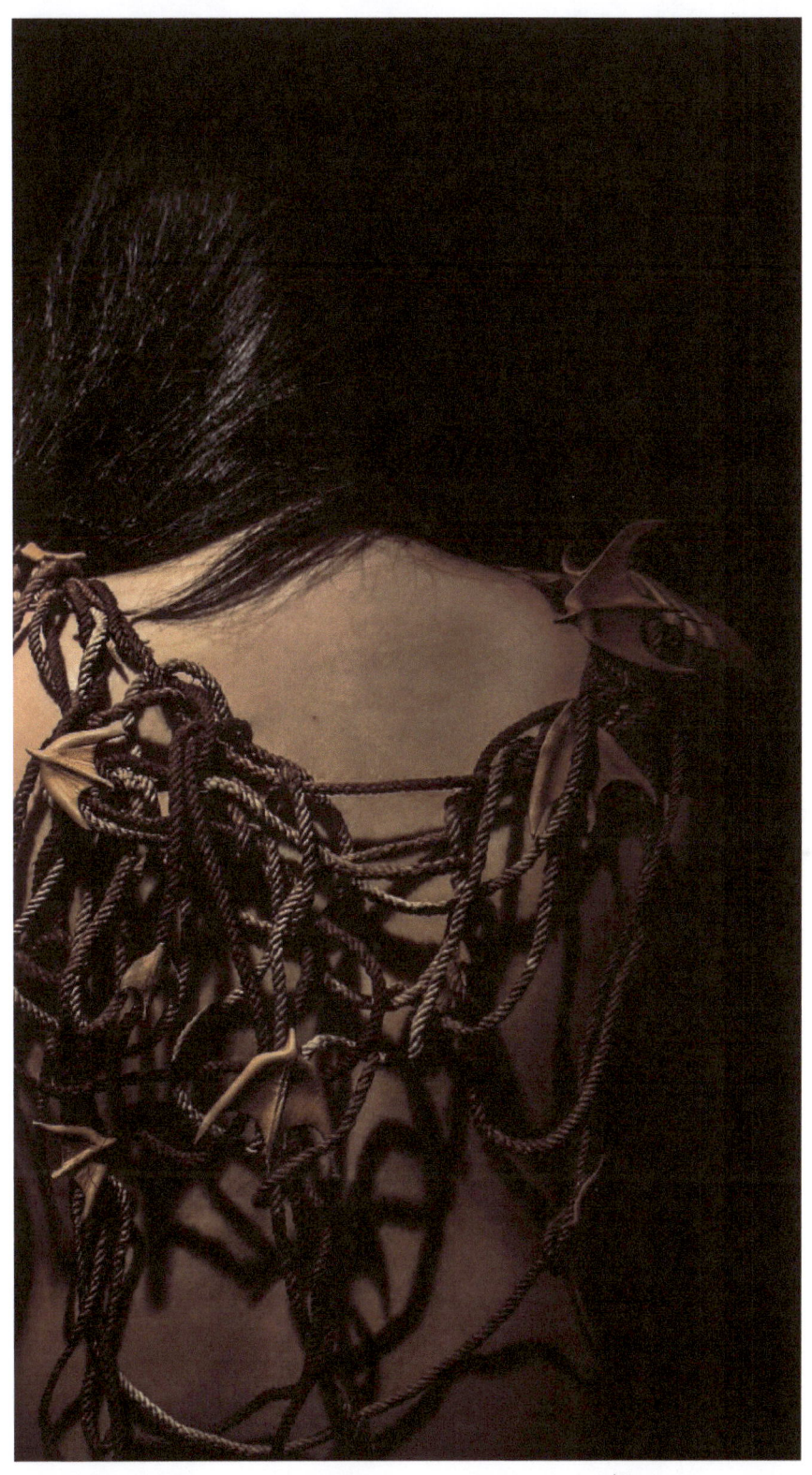

iliana tzelepi

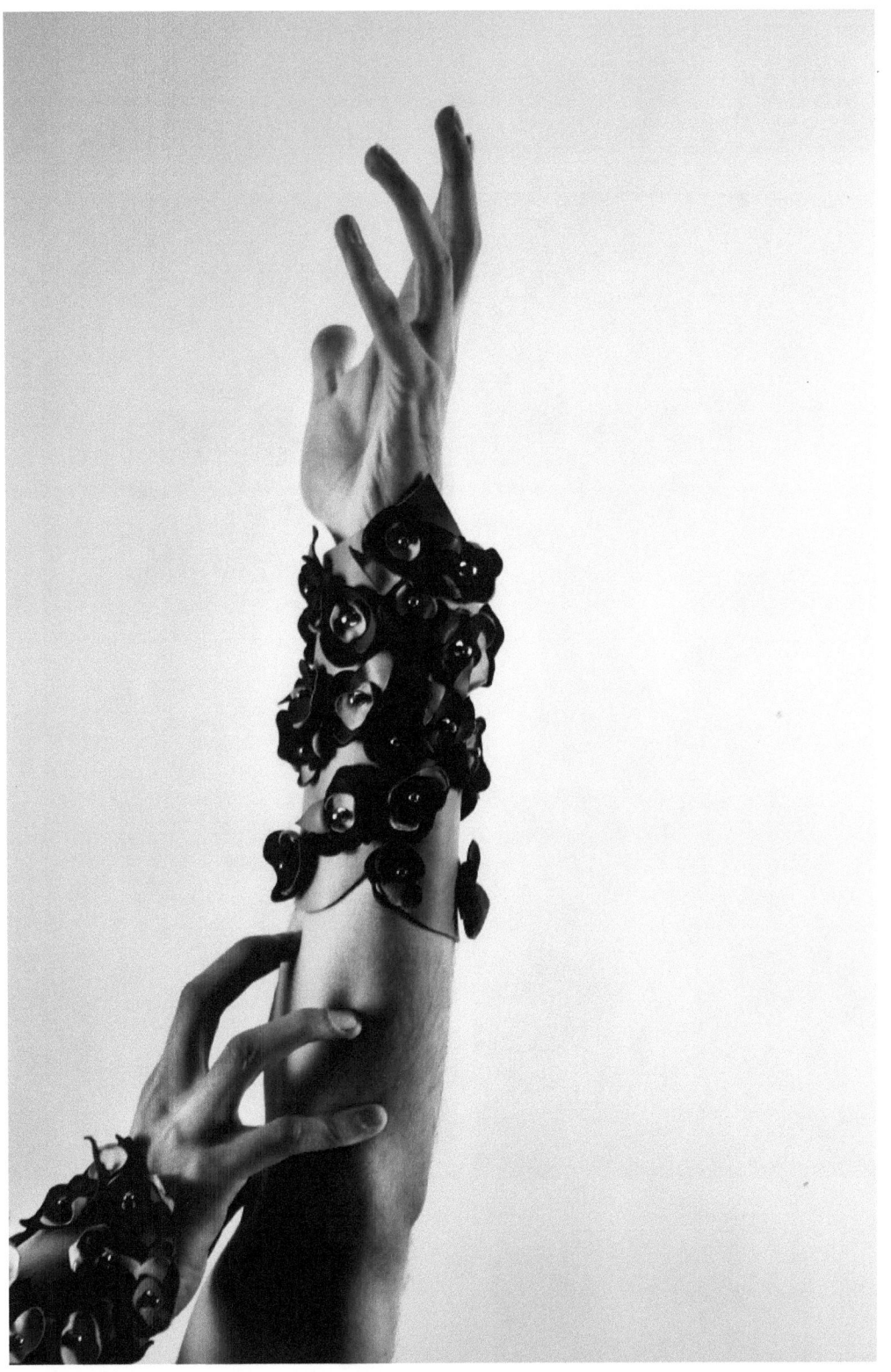

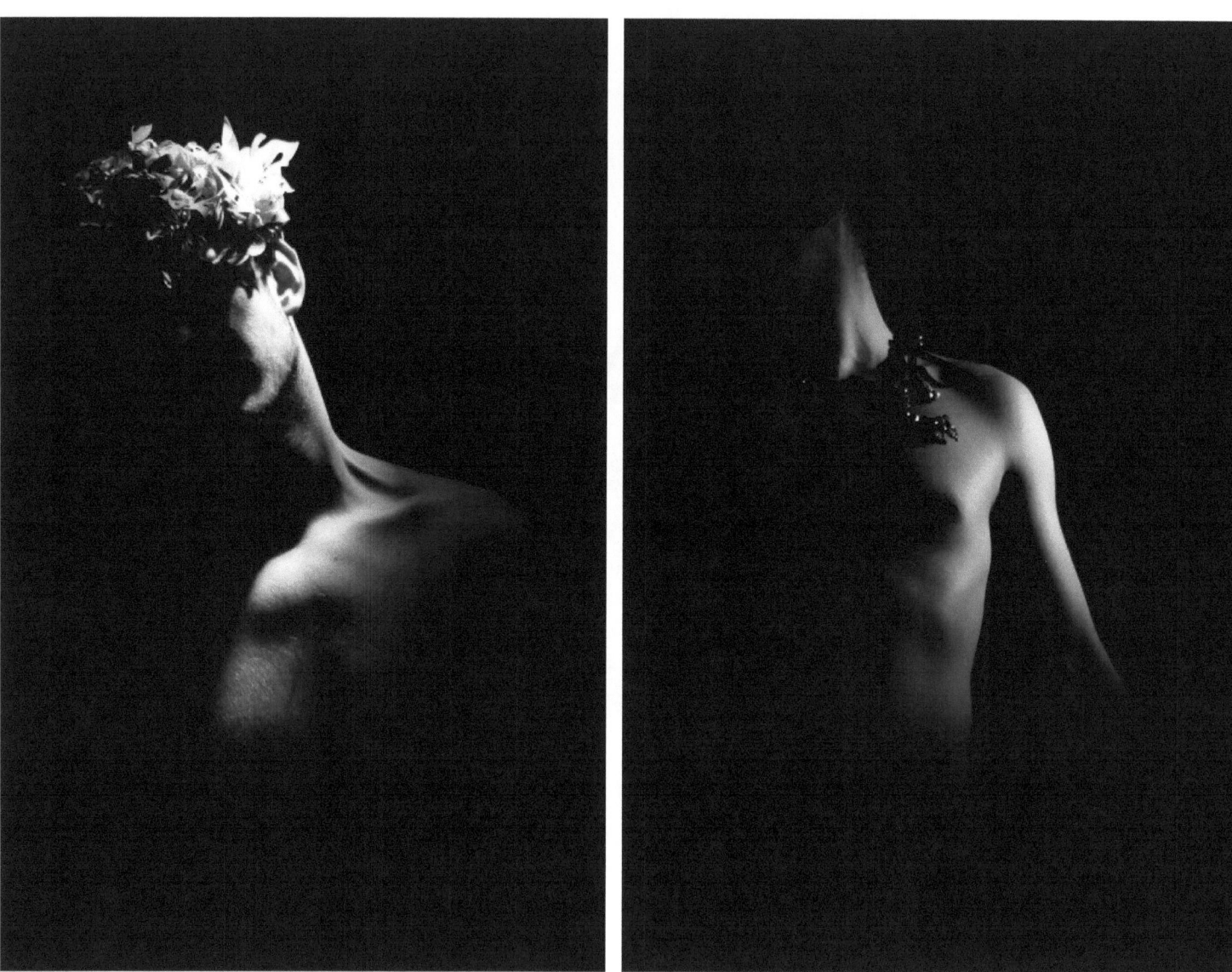

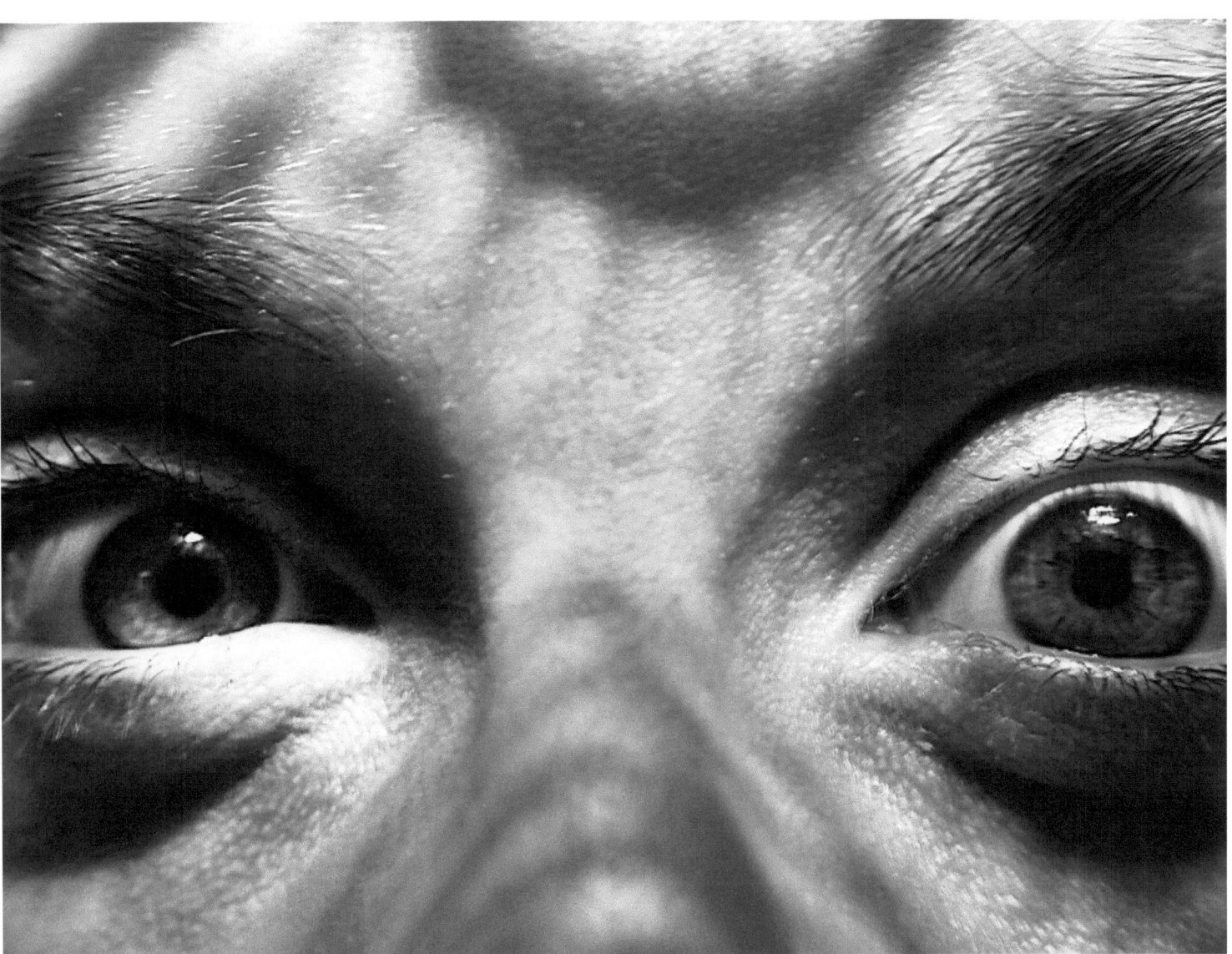

marina kappou

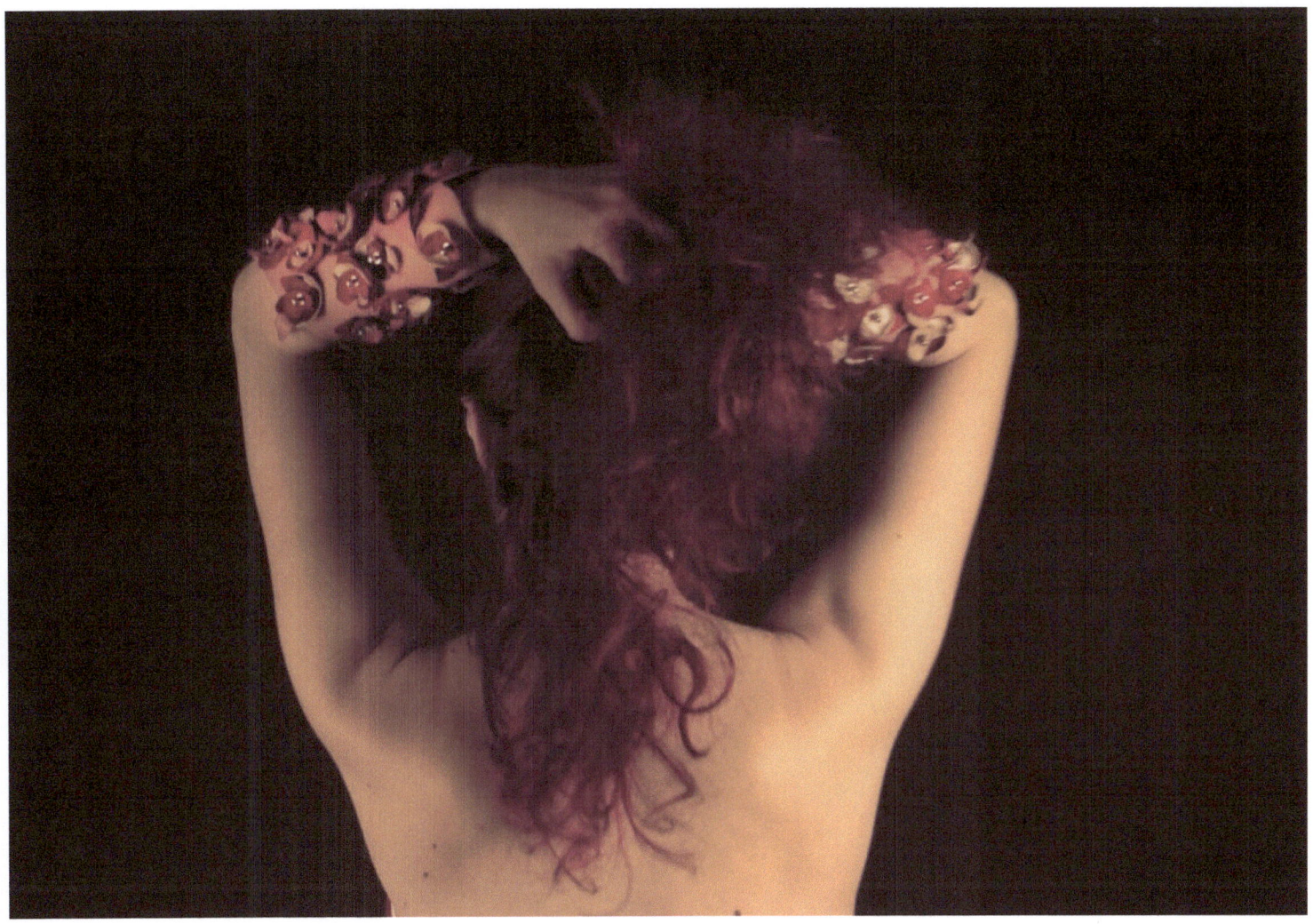

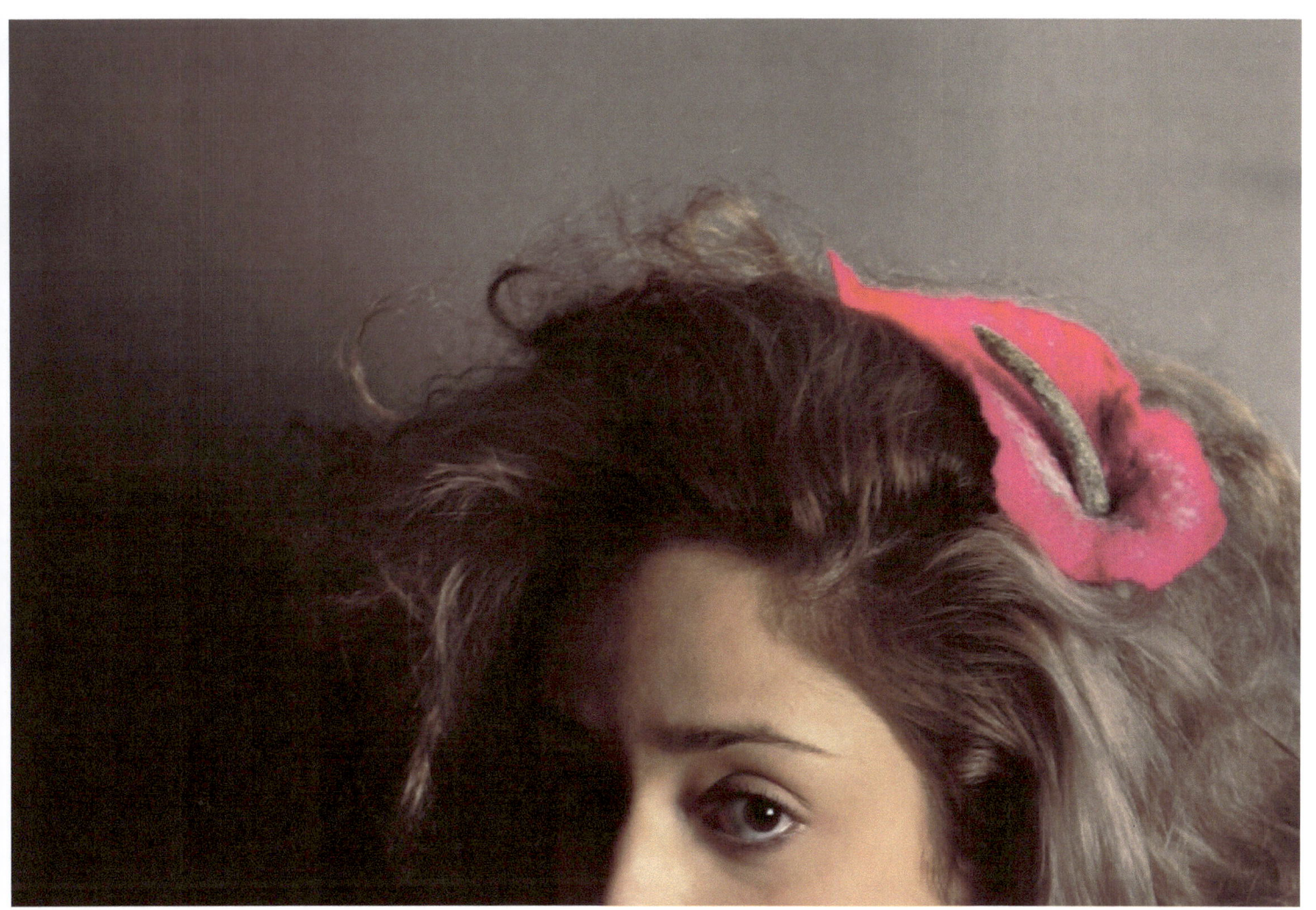

stamatia kouzeli

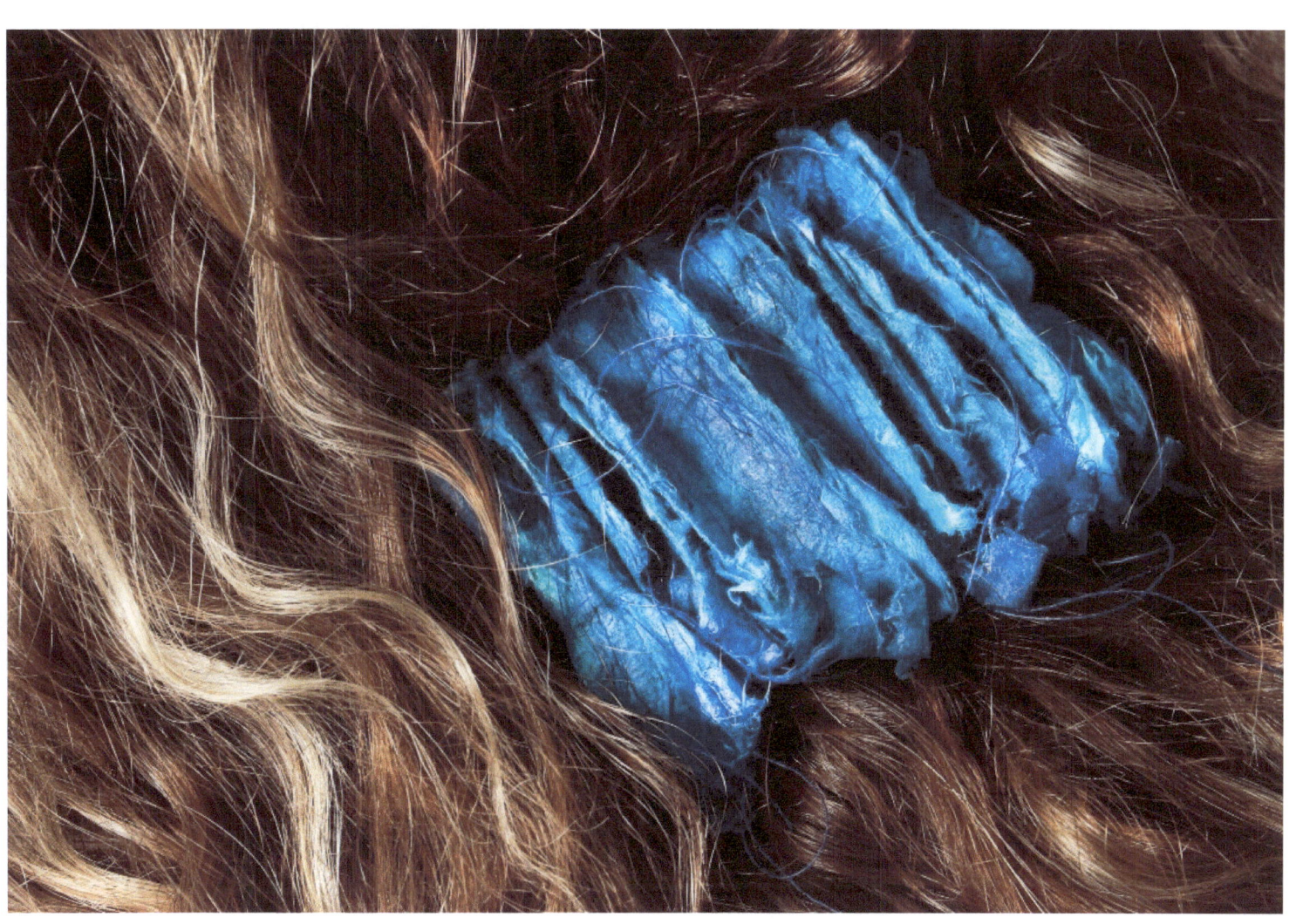

stamatia melissourgou

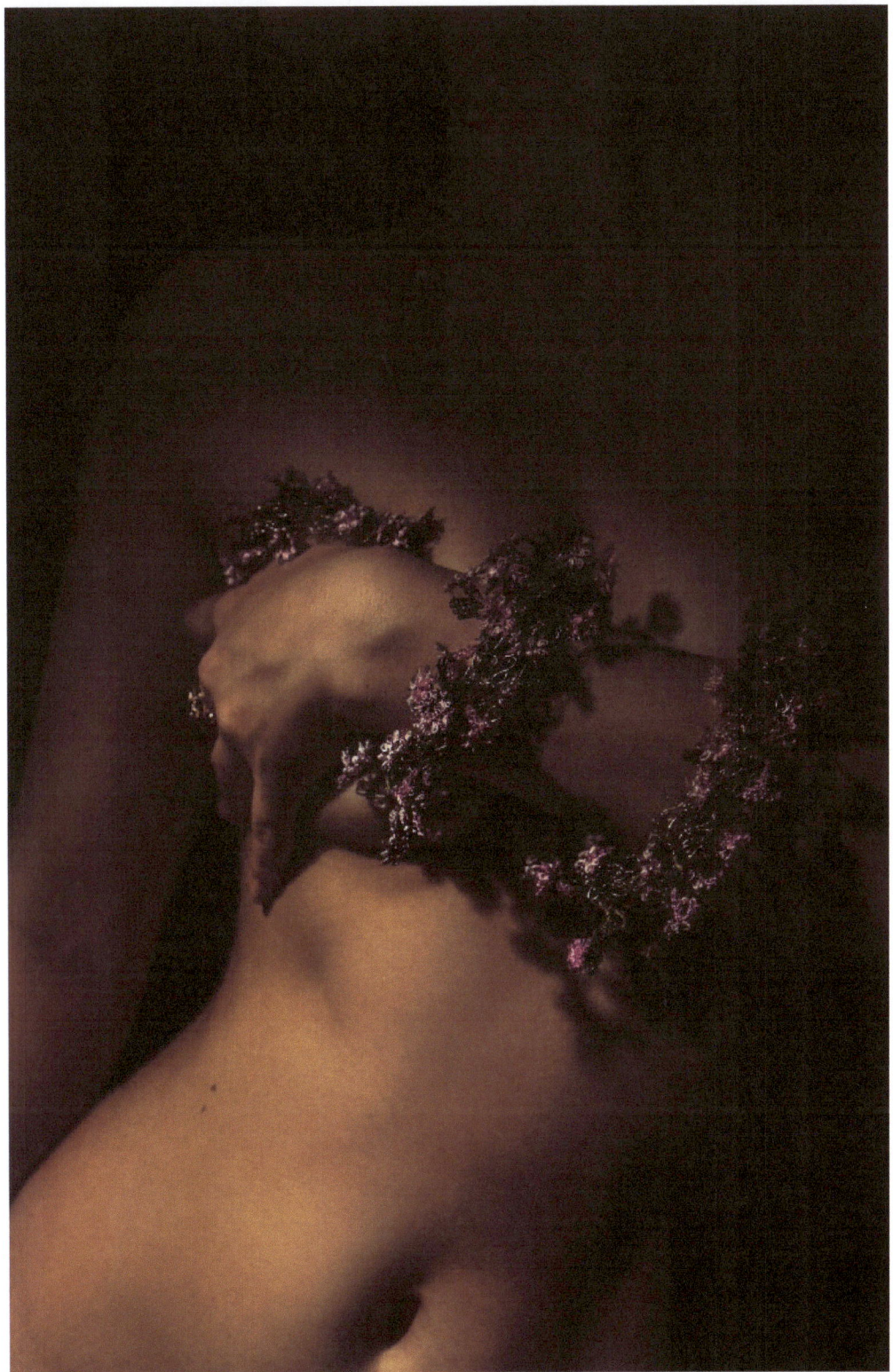

www.ingramcontent.com/pod-product-compliance
Lightning Source LLC
Chambersburg PA
CBHW050739180526
45159CB00003B/1288